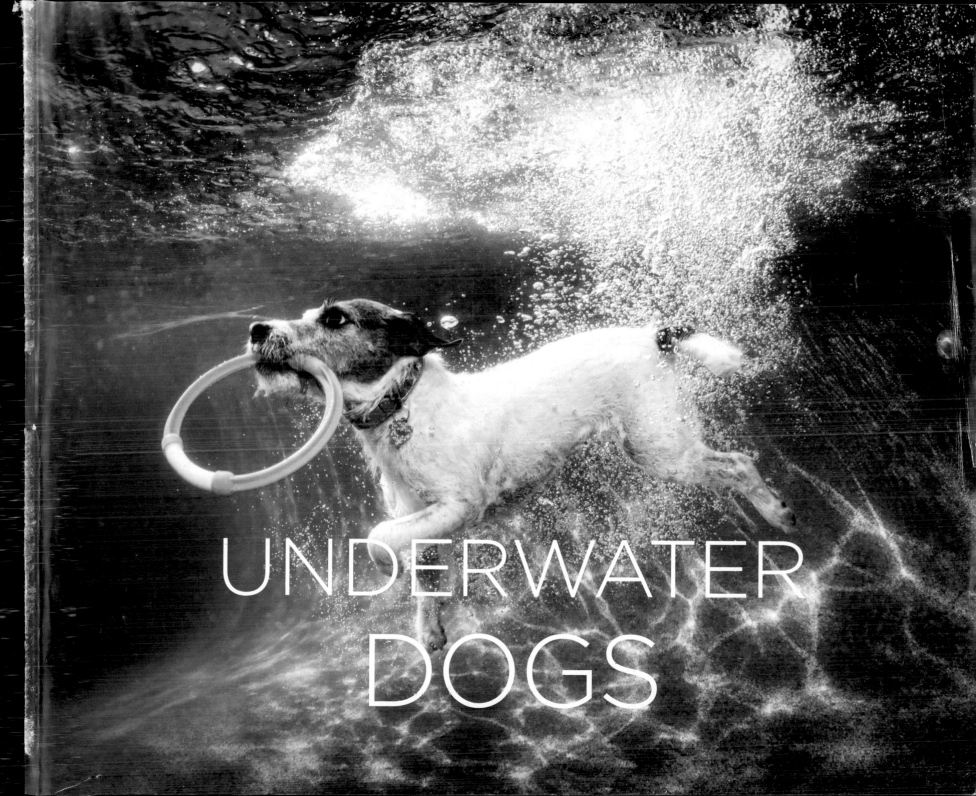

UNDERWATER
DOGS

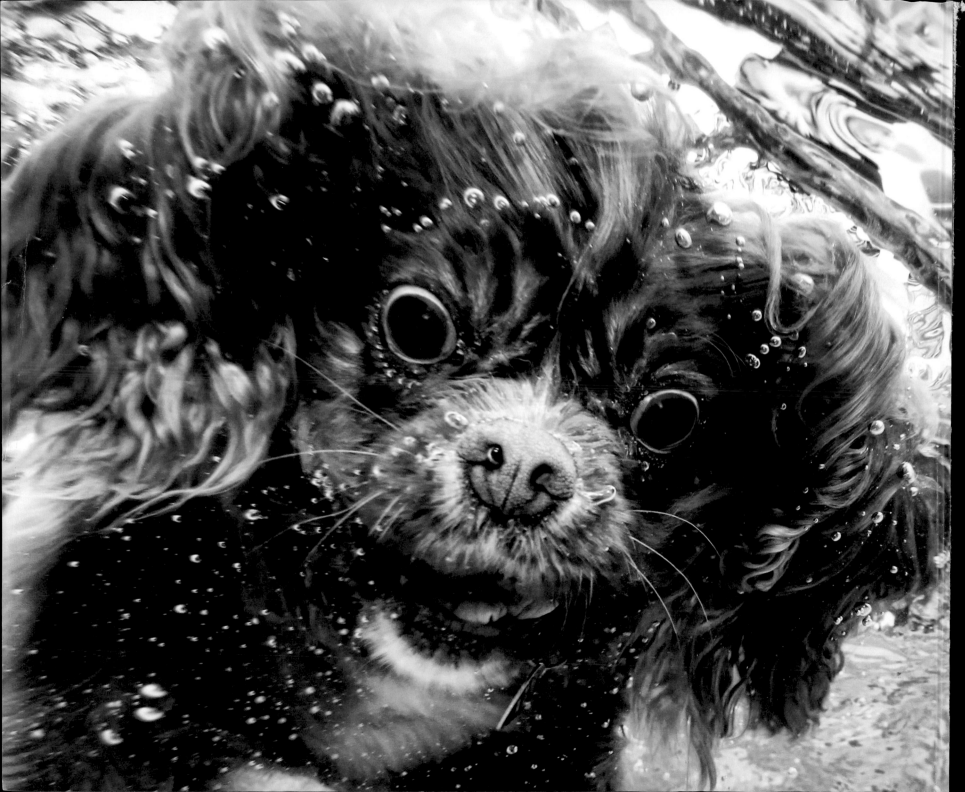

UNDERWATER DOGS

SETH CASTEEL

headline

First published in Great Britain in 2012 by
HEADLINE PUBLISHING GROUP

1

Cataloguing in Publication Data is
available from the British Library

Hardback ISBN 978 0 7553 6411 4

Printed and bound in Italy by Rotolito Lombarda S.p.A.

Headline's policy is to use papers that are natural,
renewable and recyclable products and made from
wood grown in sustainable forests. The logging and
manufacturing processes are expected to conform to
the environmental regulations of the country of origin.

HEADLINE PUBLISHING GROUP
An Hachette UK Company
338 Euston Road
London NW1 3BH

www.headline.co.uk
www.hachette.co.uk

I dedicate this book to dogs everywhere, for their unconditional love and friendship. Your selflessness and positive outlook on life inspire me every single day!

Contents

Murphy

American Pit Bull Terrier Mix, 1 year

Introduction

On a lifestyle photo shoot in 2010, I was working with a Cavalier King Charles Spaniel named Buster in a backyard in Orange, California. The photo shoot was meant to be "on land." Roll around in the grass, eat some treats, dig a hole, take a nap. I am talking about the dog, of course, although these things are part of my routine, too.

SPLASH! It wasn't long before Buster went headfirst into the pool, emerging as a totally different-looking dog. And then SPLASH again. The "on land" shoot was now officially an "in the pool" shoot. I was snapping away, but I quickly realized that these weren't the shots I needed. Buster was actually submerging during his pool rampage as he pursued a small tennis ball that he would knock in on his own. I thought, *Hmm, what does he look like under the water?*

I left, bought a point-and-shoot underwater camera, zipped back, and jumped in. The resulting photos would be the beginning of this series of underwater dogs.

Through the course of shooting, I have worked under the water with more than 250 dogs. Labs. Goldens. A Boston Terrier. A Yorkie. A Pug. Most of the dogs featured in this book had never been underwater until they met me, and some had never even been swimming! Not only did they participate of their own free will but they had fun! This is what I love about dogs – their attitude toward life.

I am passionate about dogs' unique personalities. Their range of emotion is similar to ours. That is why we relate to them, and why they relate to us, and why together we forge deep friendships.

My series of underwater photos shows a side of dogs that we never get to see. If you look at a Dachshund, for example, you do not see any evidence of a wolf, but it's there, somewhere deep within. Modern dogs are domesticated animals who embrace their friendship with humankind, but they also have a primitive side, and they jump at the chance to get in touch with their wild instincts.

Sometimes all it takes is the toss of a ball and an invitation into the water.

Underwater, dogs show vividly what retrieving really means to them, and how wholeheartedly and intently they engage with the world.

Our dogs are our heroes. They teach us that if you just jump in, you might have fun along the way.

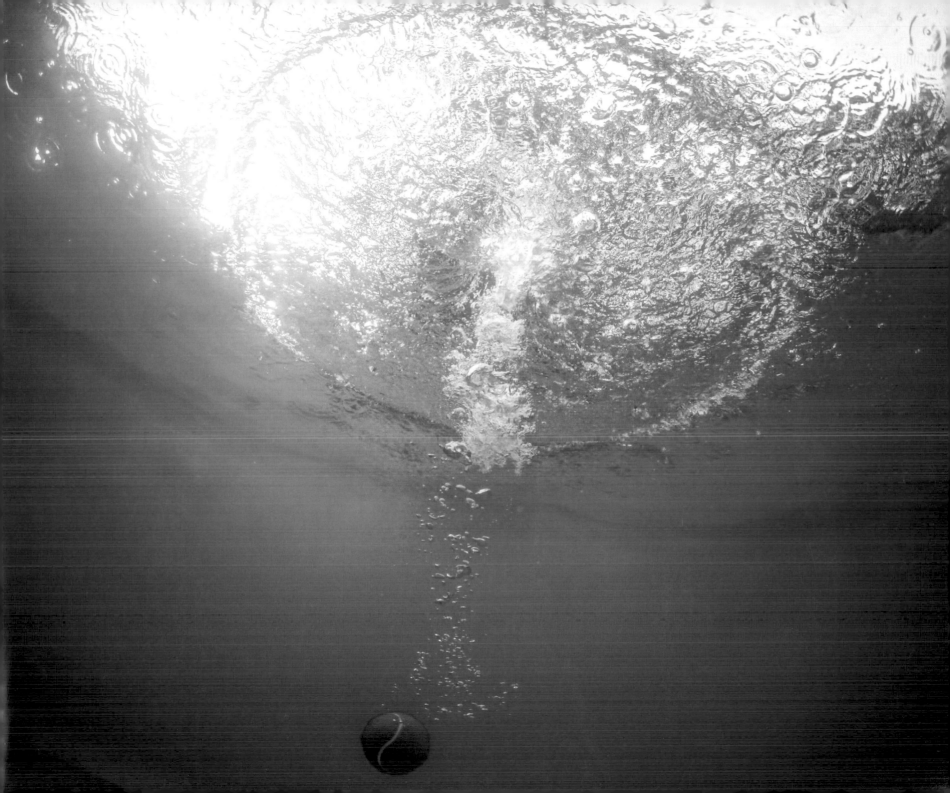

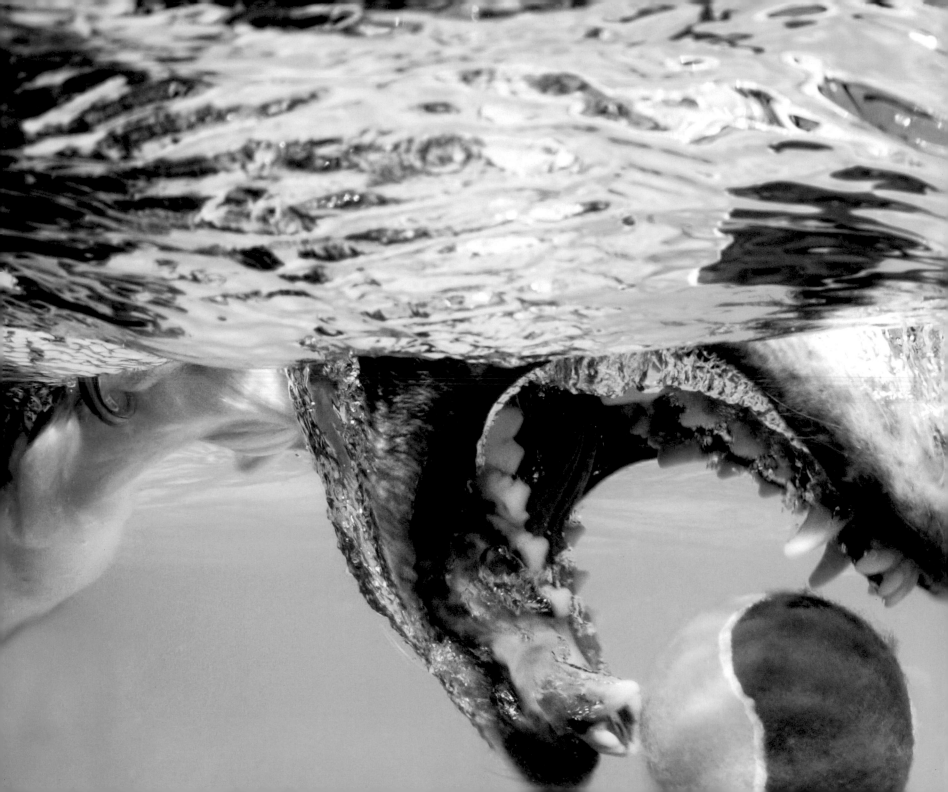

UNDERWATER
DOGS

Gidget
Border Collie, 6 years

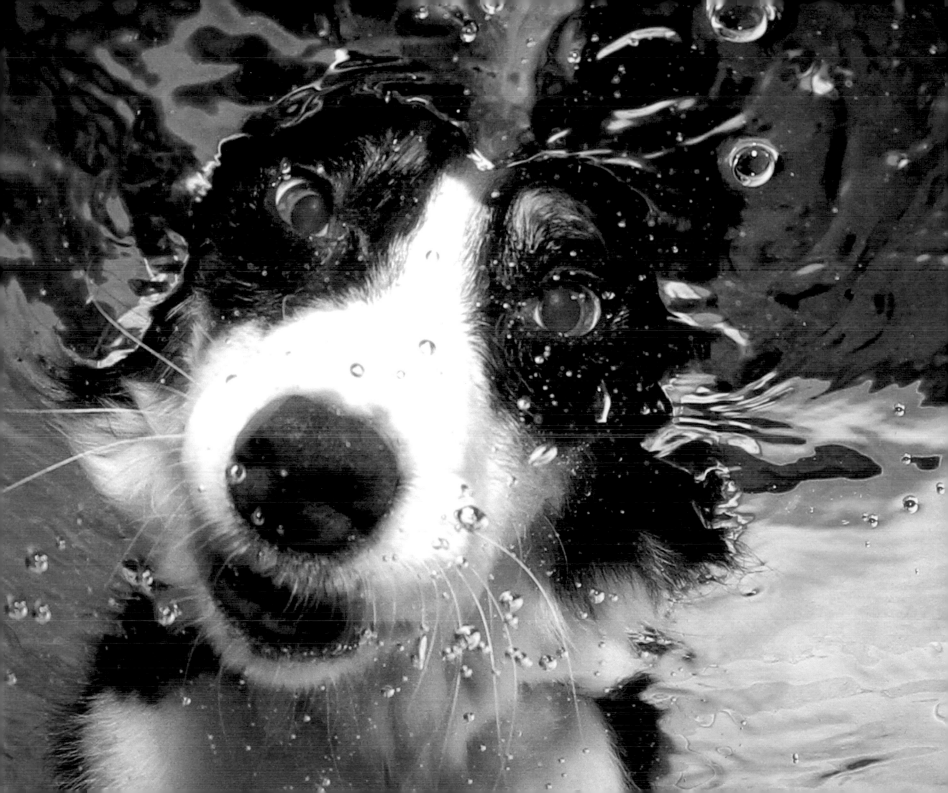

Apollo
Red Labrador Retriever, 8 years

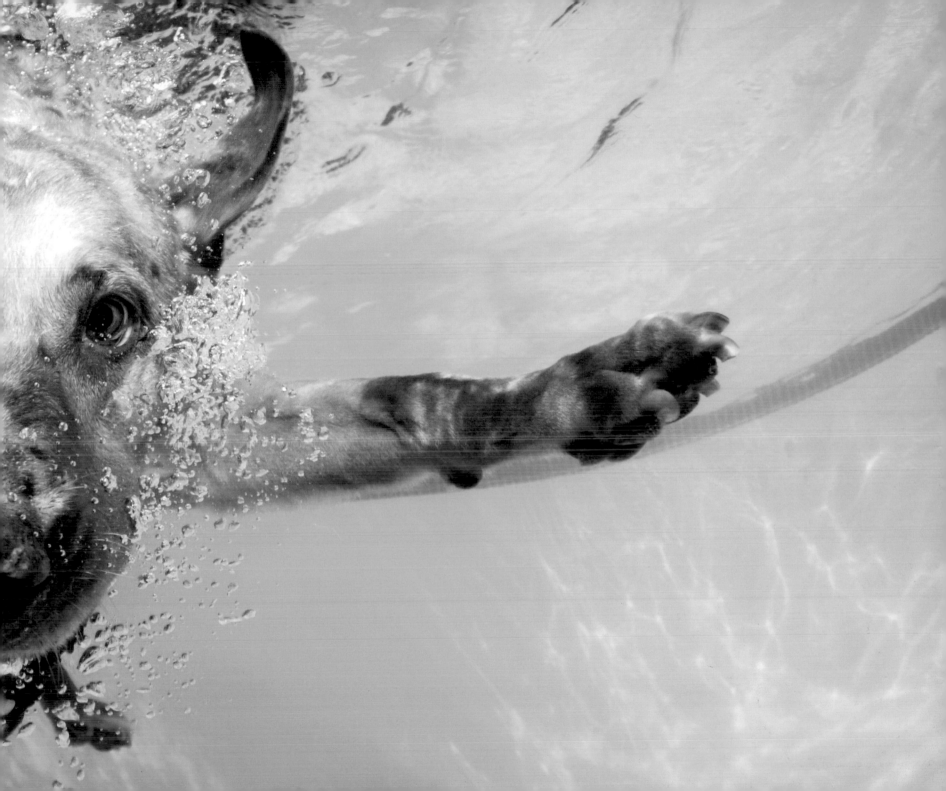

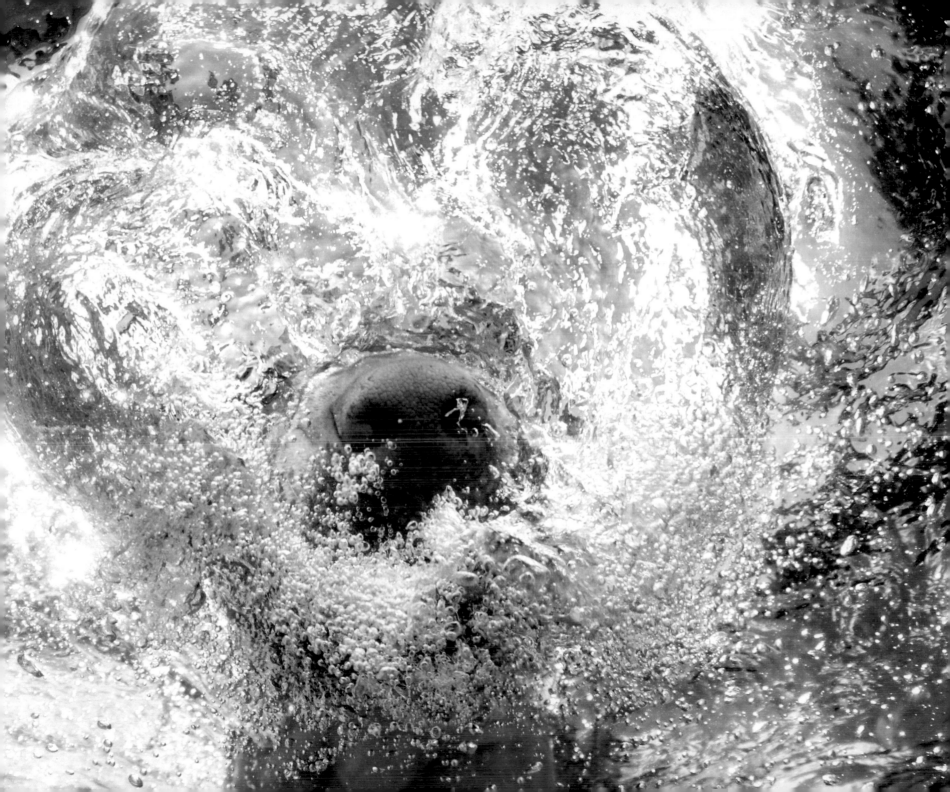

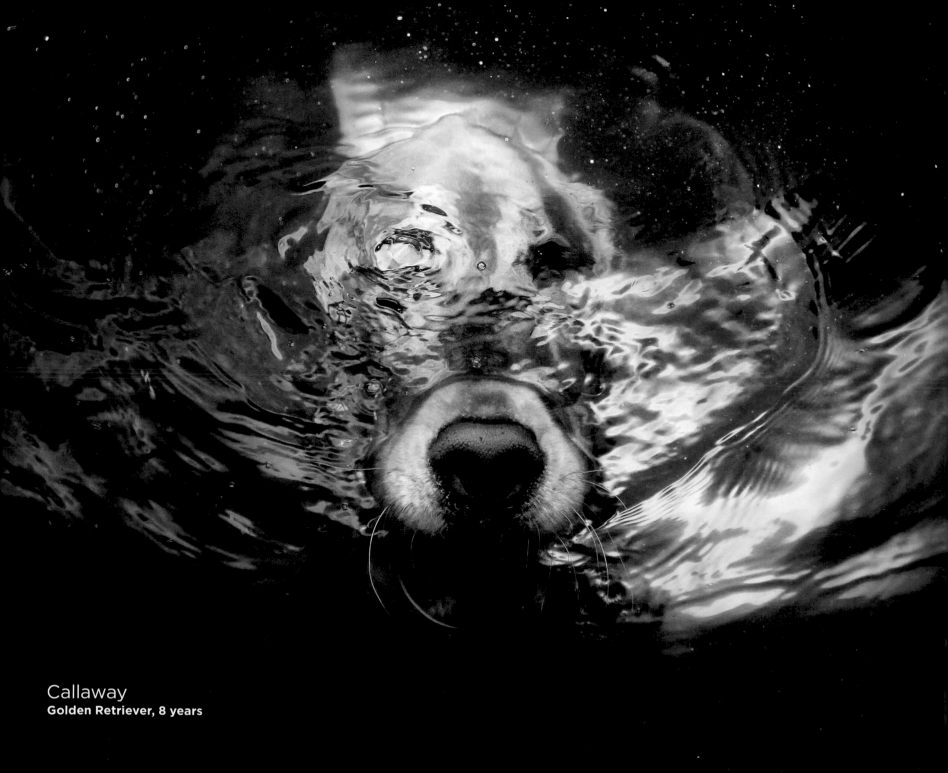

Callaway
Golden Retriever, 8 years

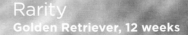
Rarity
Golden Retriever, 12 weeks

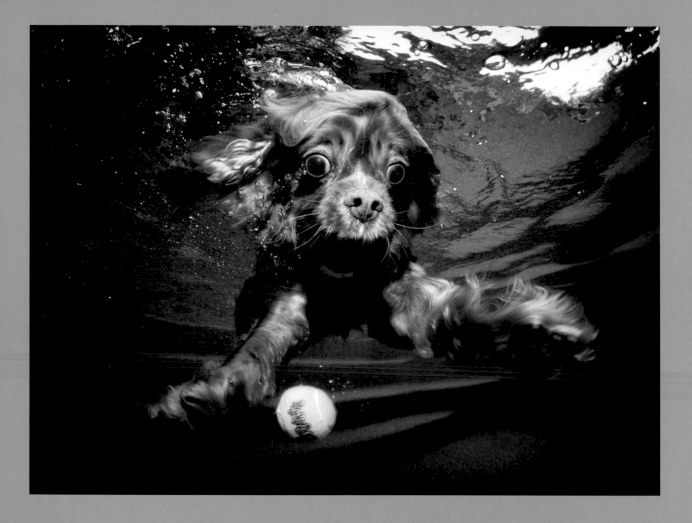

Buster
Cavalier King Charles Spaniel, 6 years

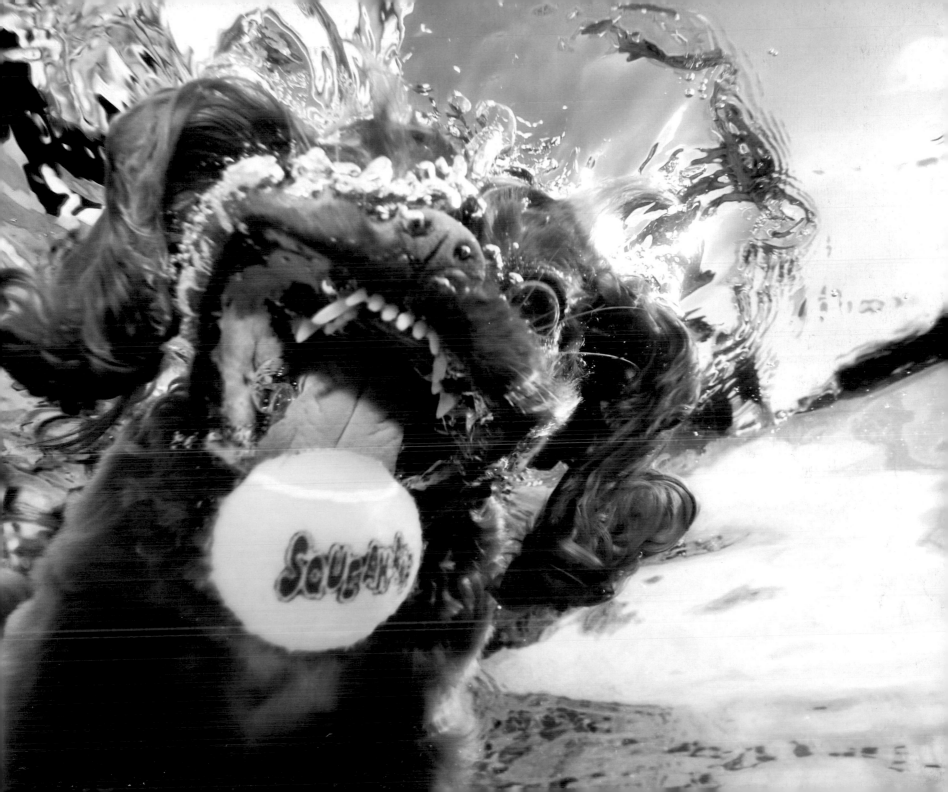

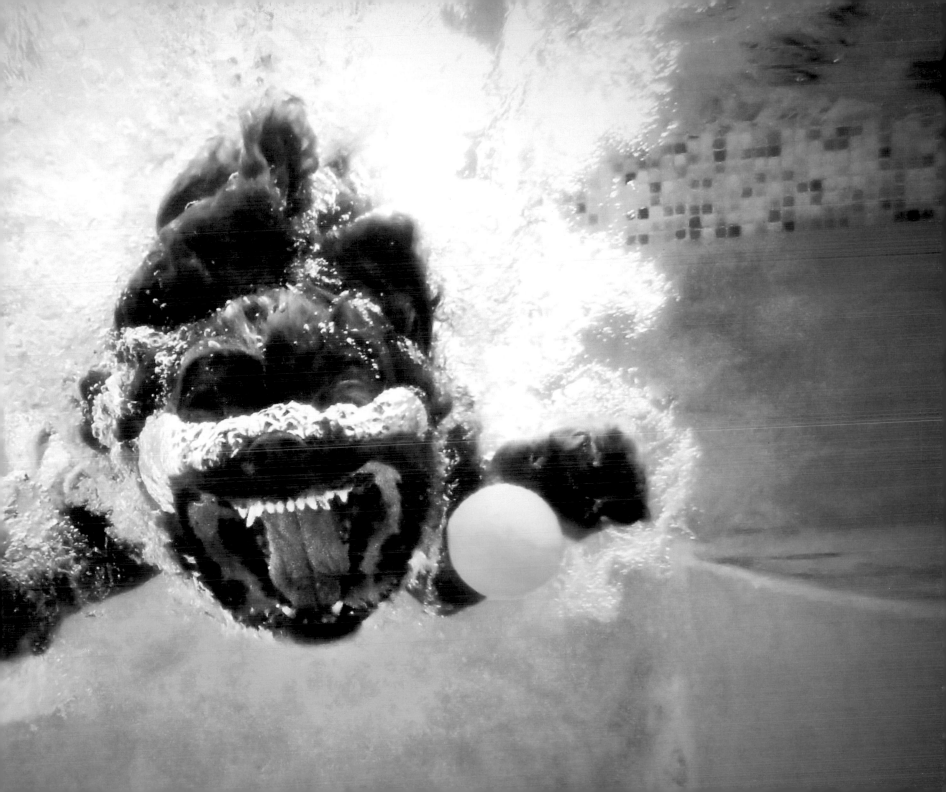

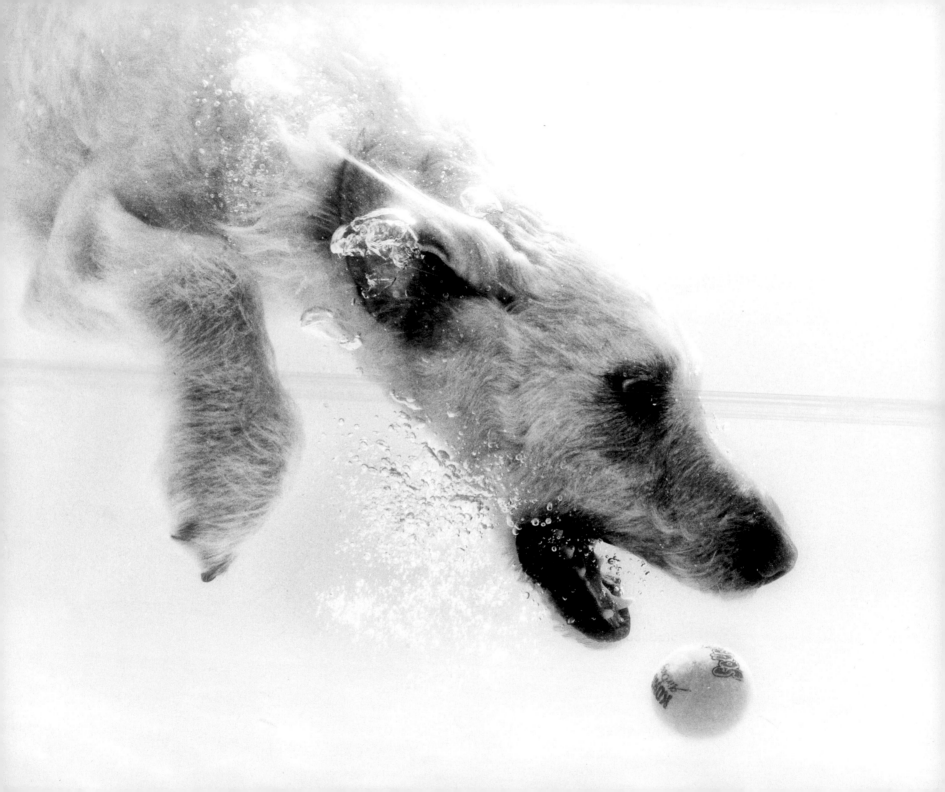

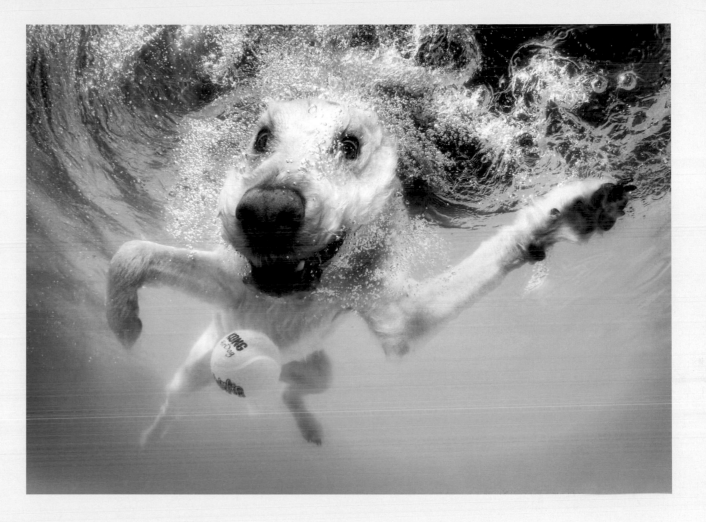

Clifford
Labradoodle, 7 years

Coraline
Olde English Bulldogge, 2 years

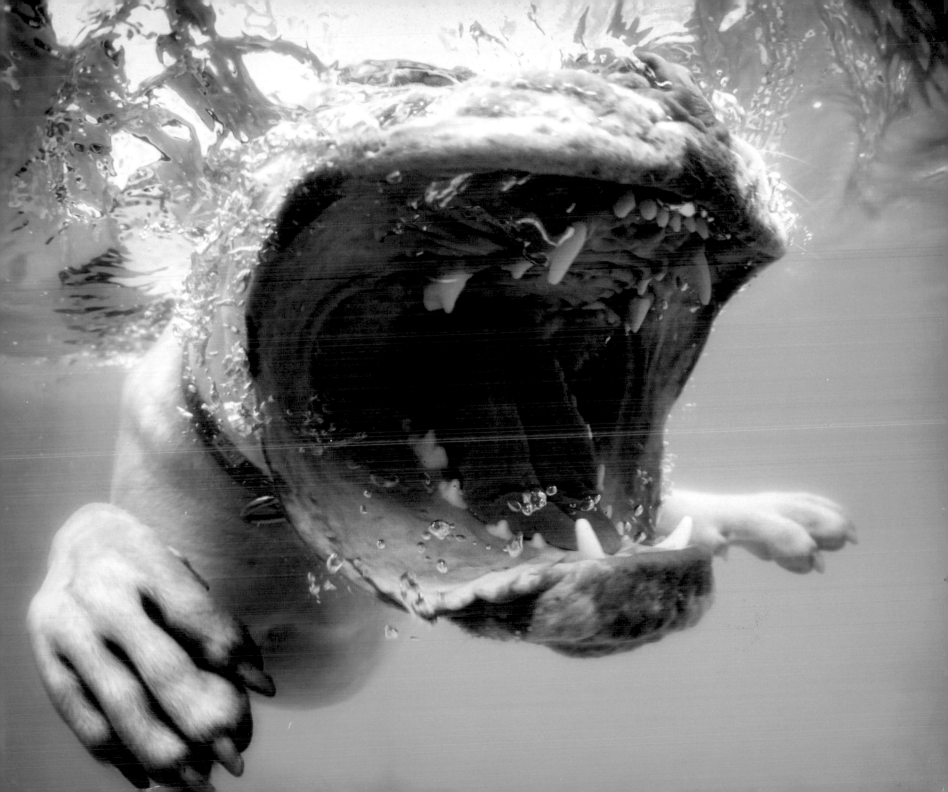

Rex
Boxer, 3 years

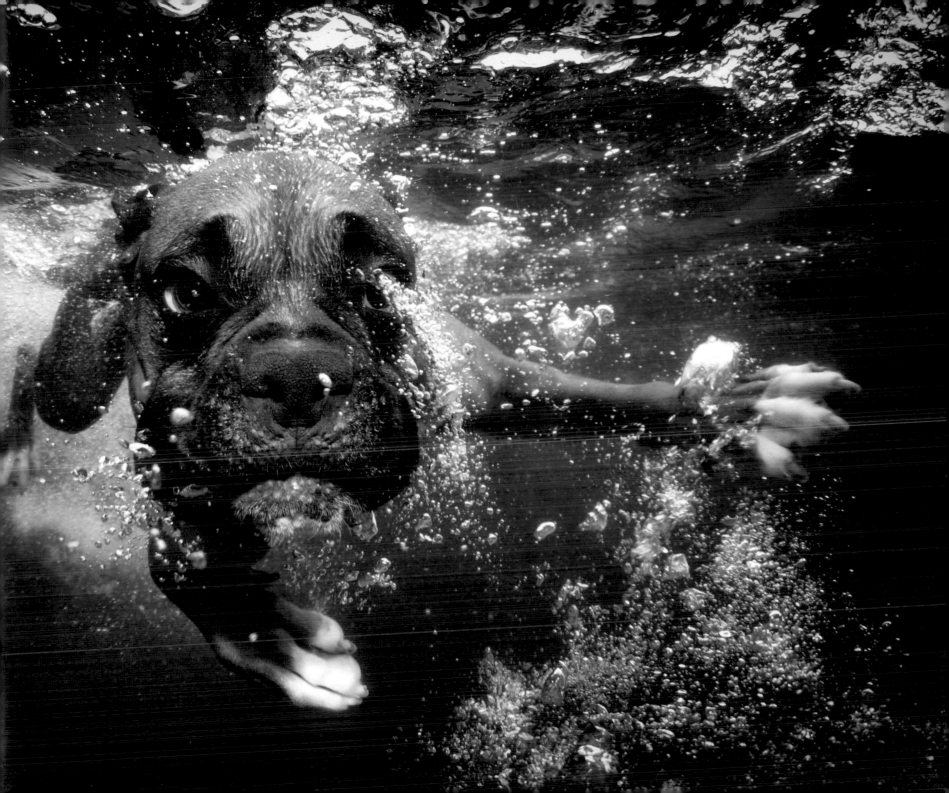

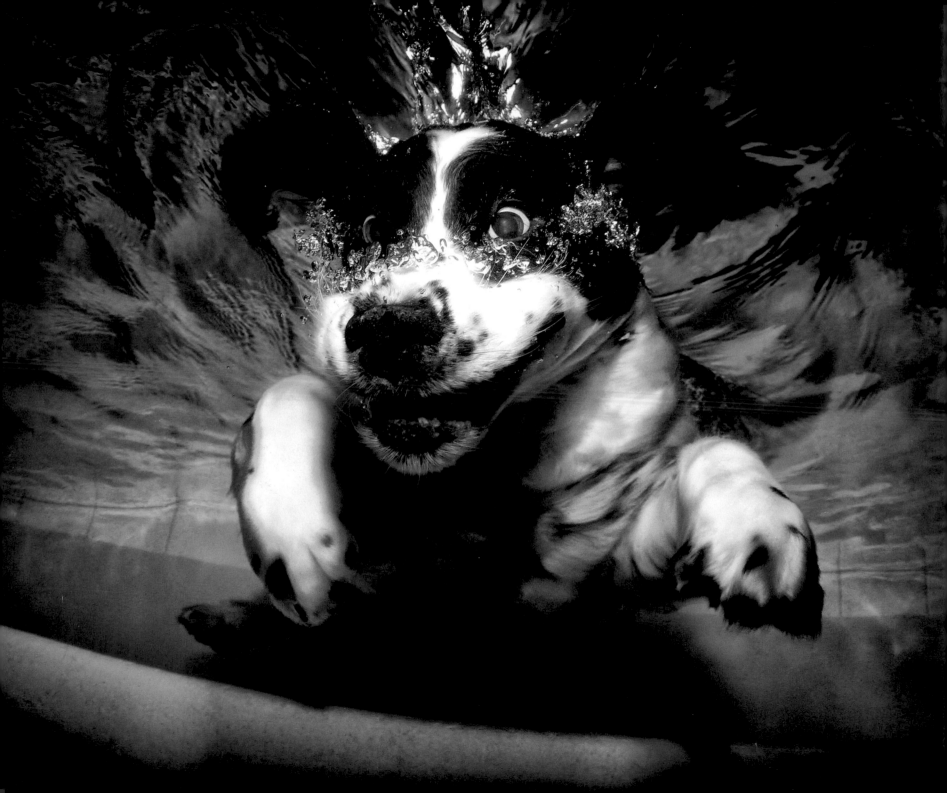

Clive
English Springer Spaniel, 8 years

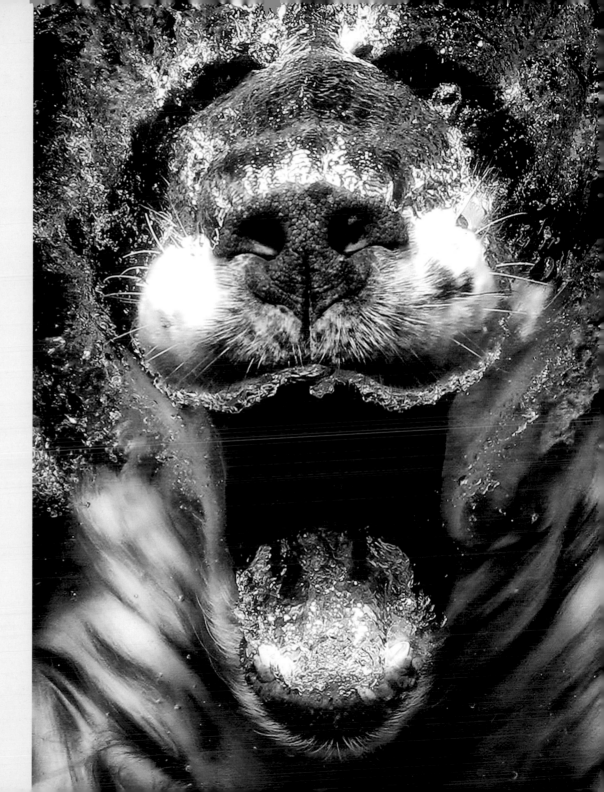

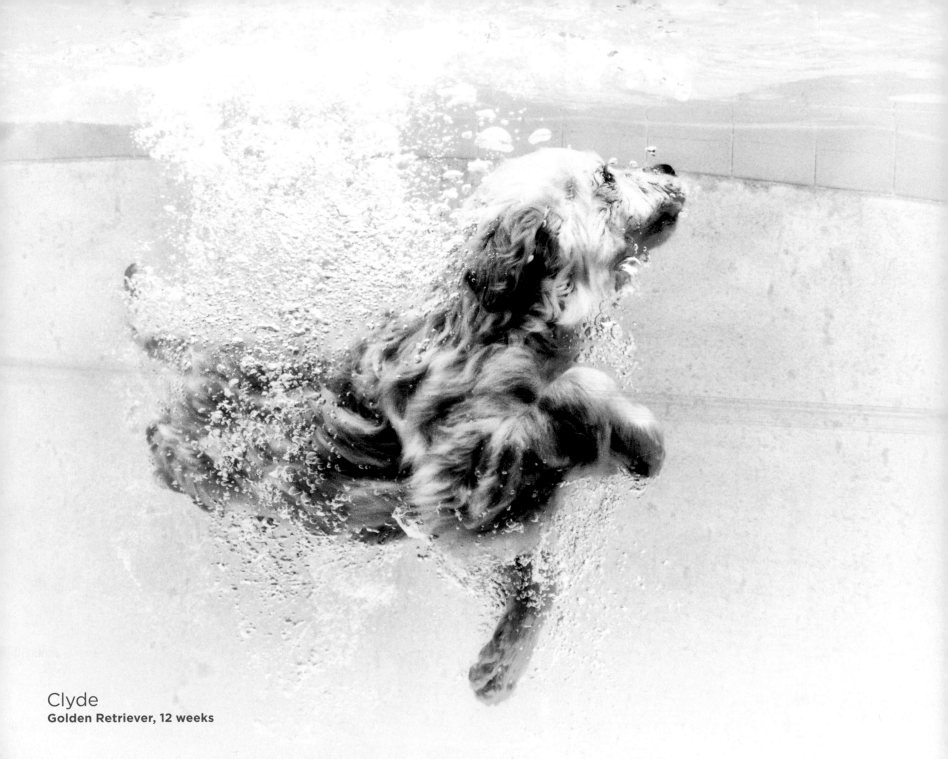

Clyde
Golden Retriever, 12 weeks

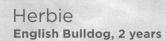

Herbie
English Bulldog, 2 years

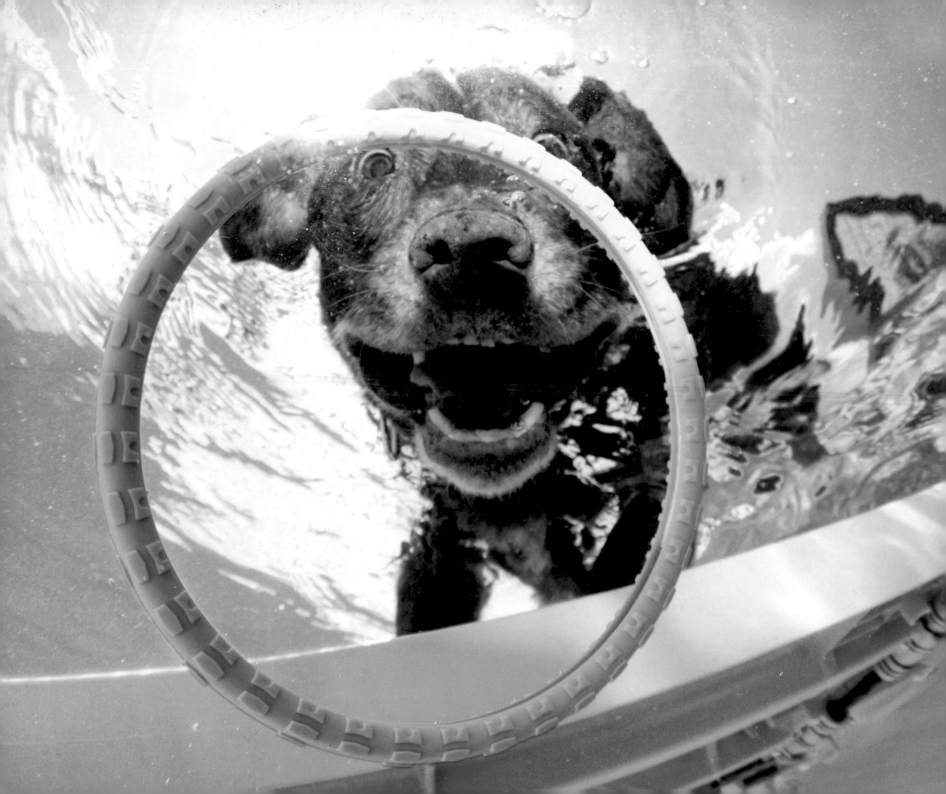

Dagmar
Chesapeake Bay Retriever, 10 years

Dakota
German Shepherd, 4 years

Sadie
Staffordshire Bull Terrier, 3 years

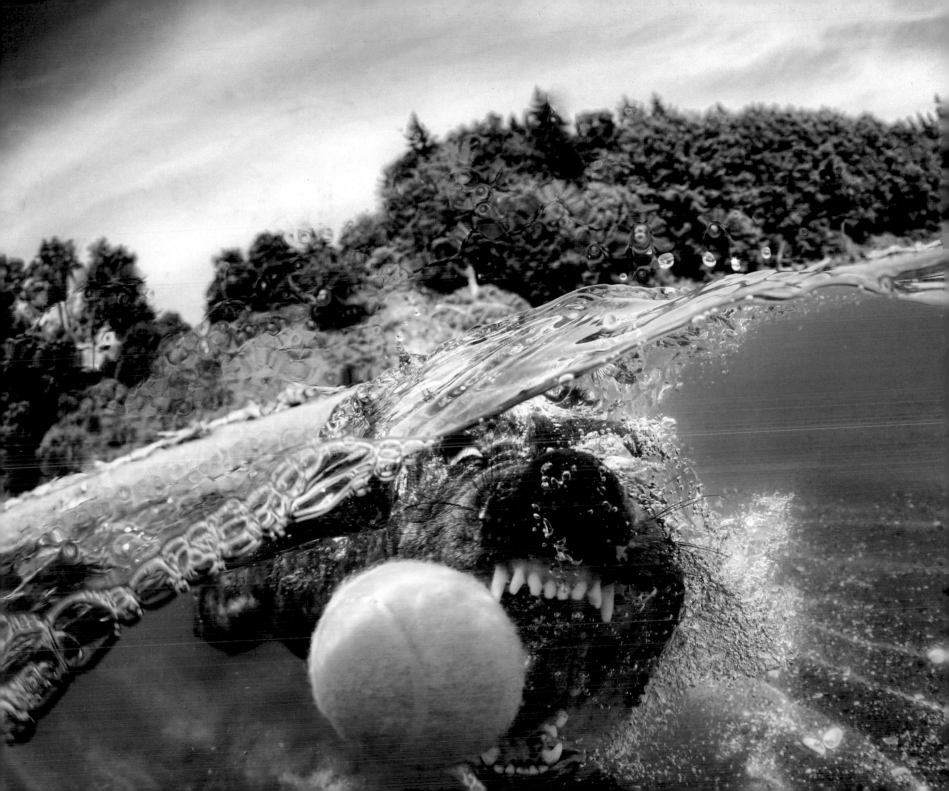

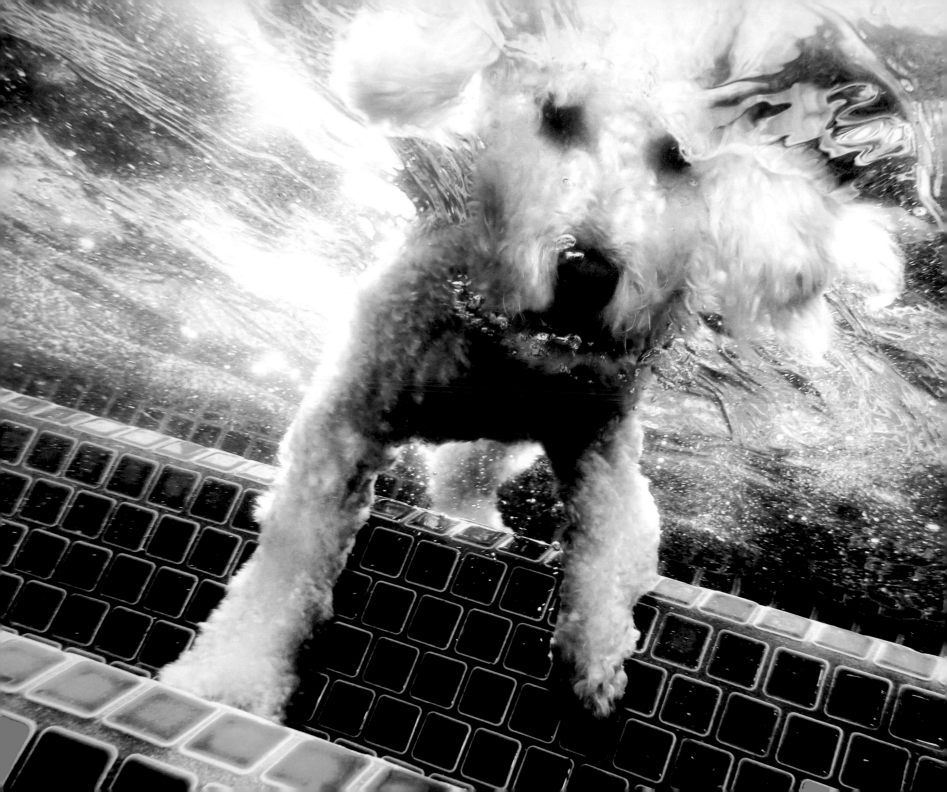

Glory
Mini-Labradoodle, 3 years

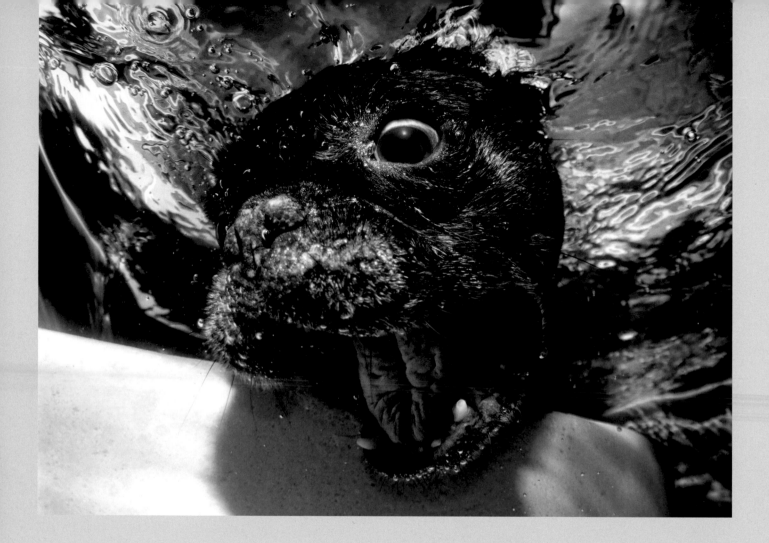

Jolie
French Bulldog, 8 years

Bardot
Yellow Labrador Retriever, 1 year

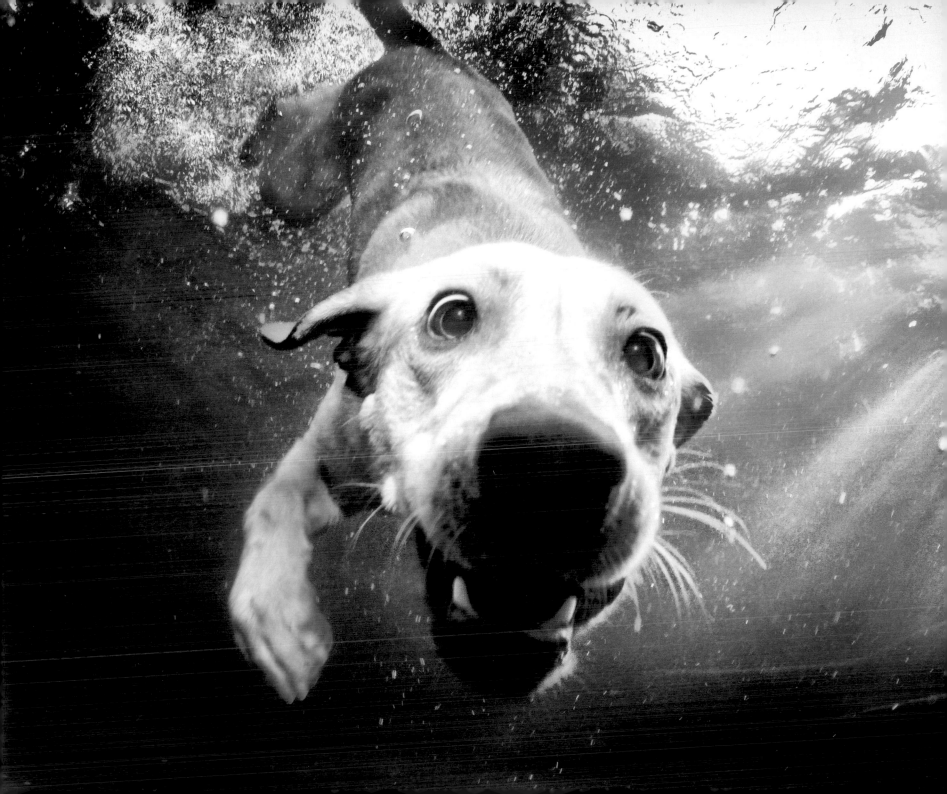

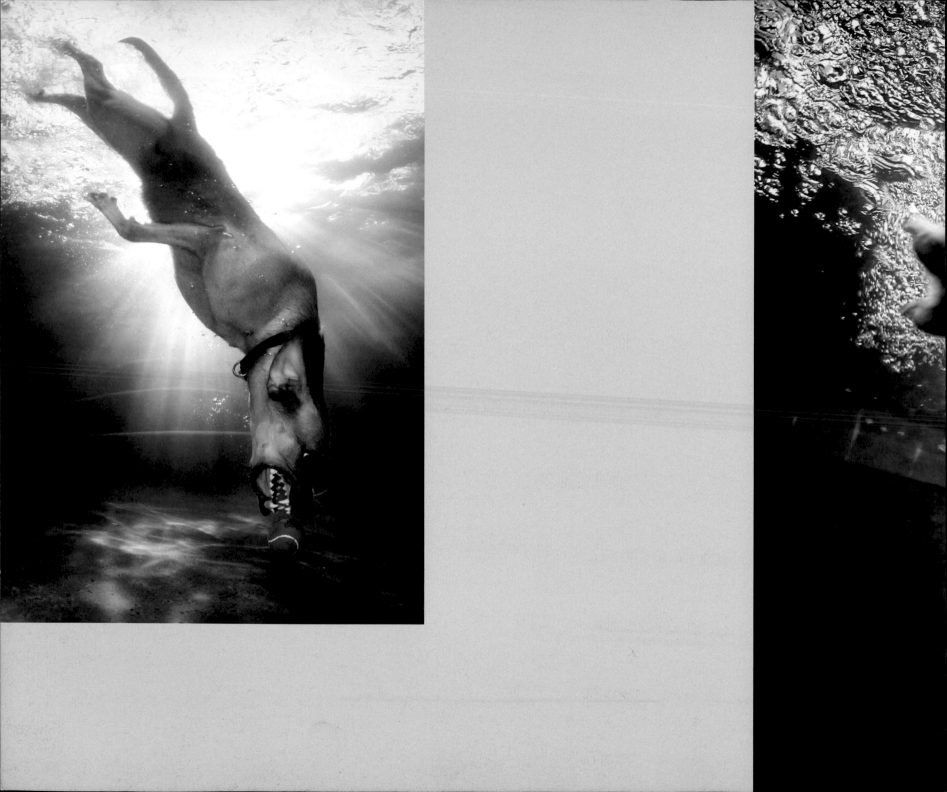

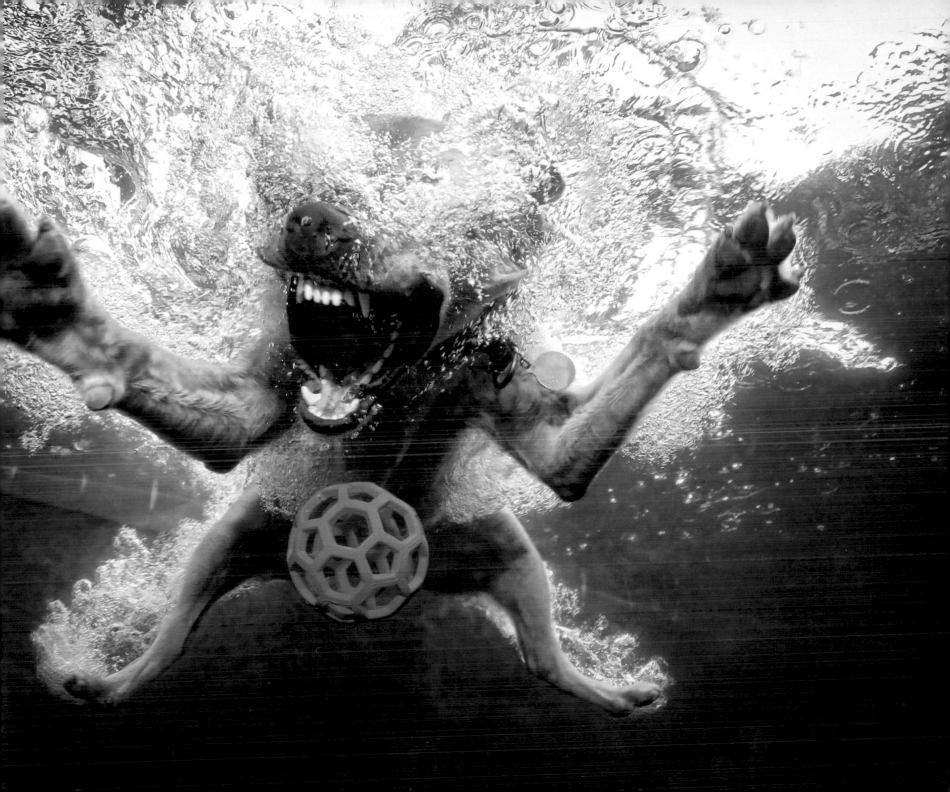

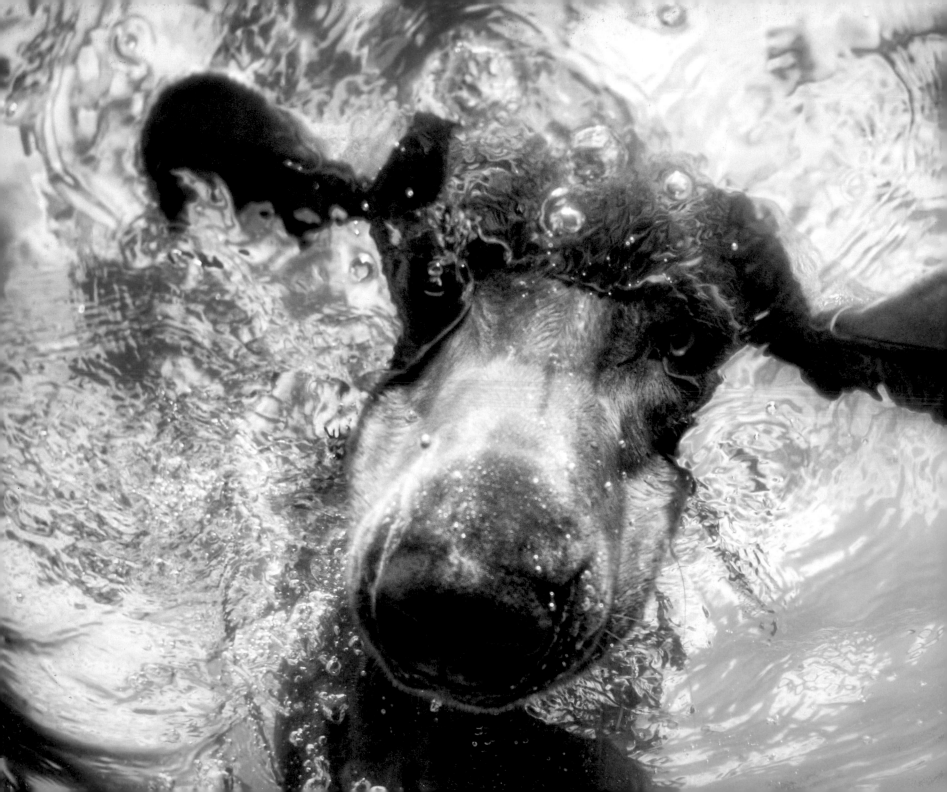

Gunnar
Weimaraner, 2 years

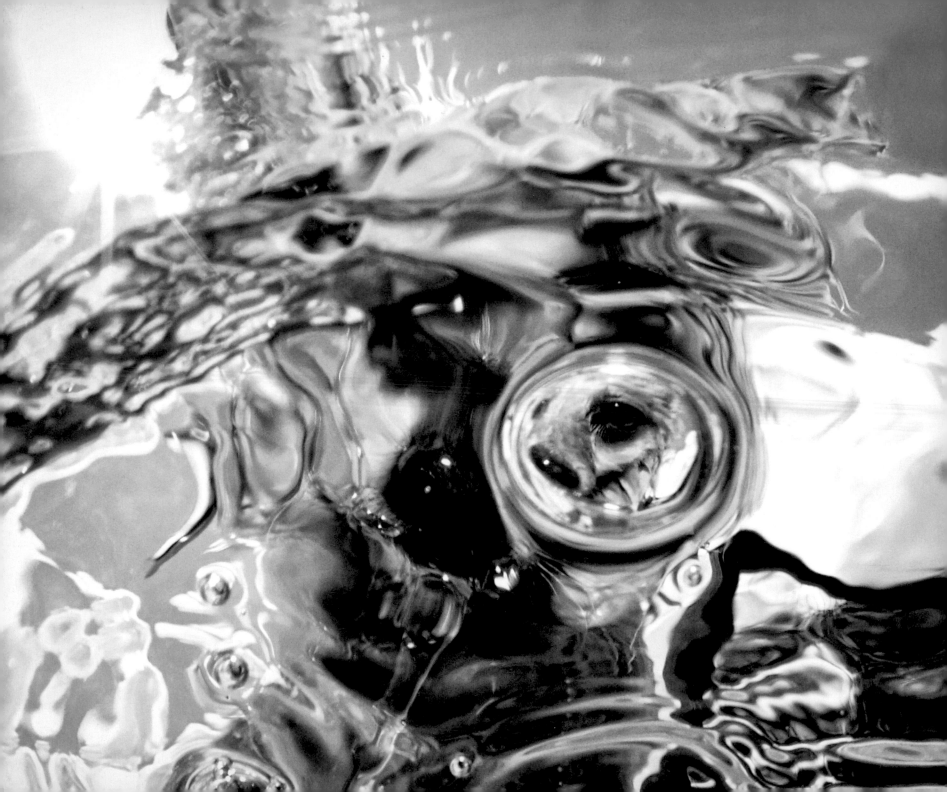

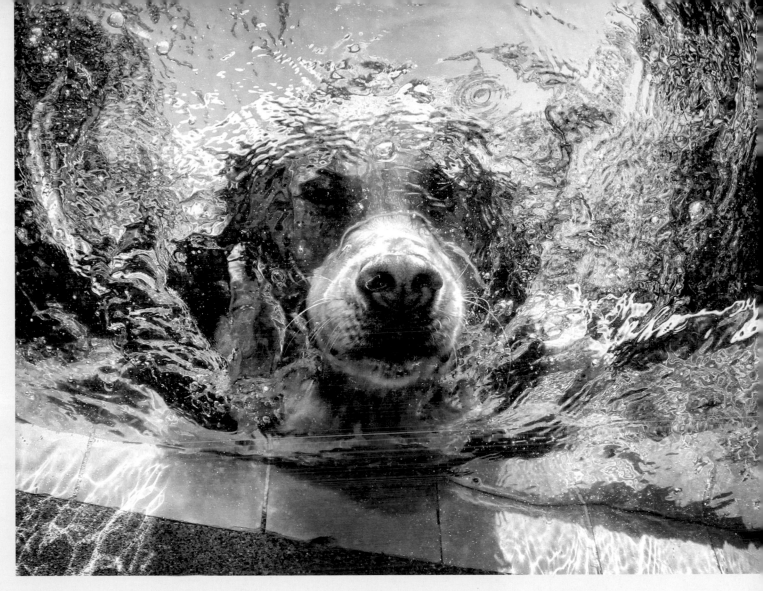

Comet
Golden Retriever, 5 years

Charlie
Pomeranian–American Eskimo Mix, 7 years

Bullet and Blade
Dobermans, 3 years

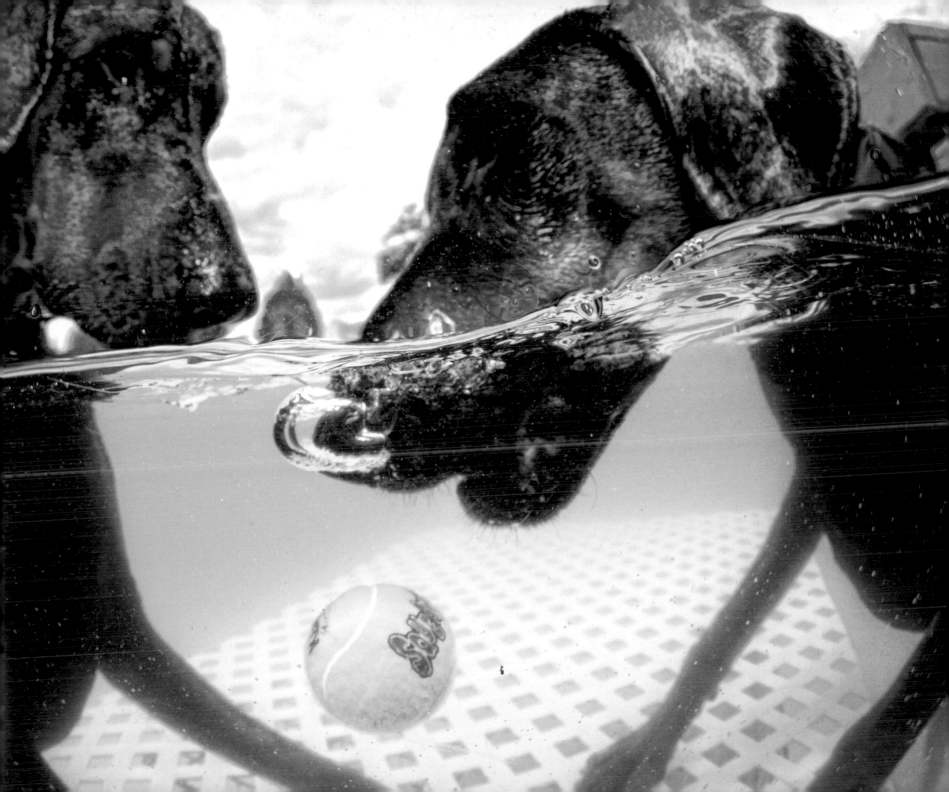

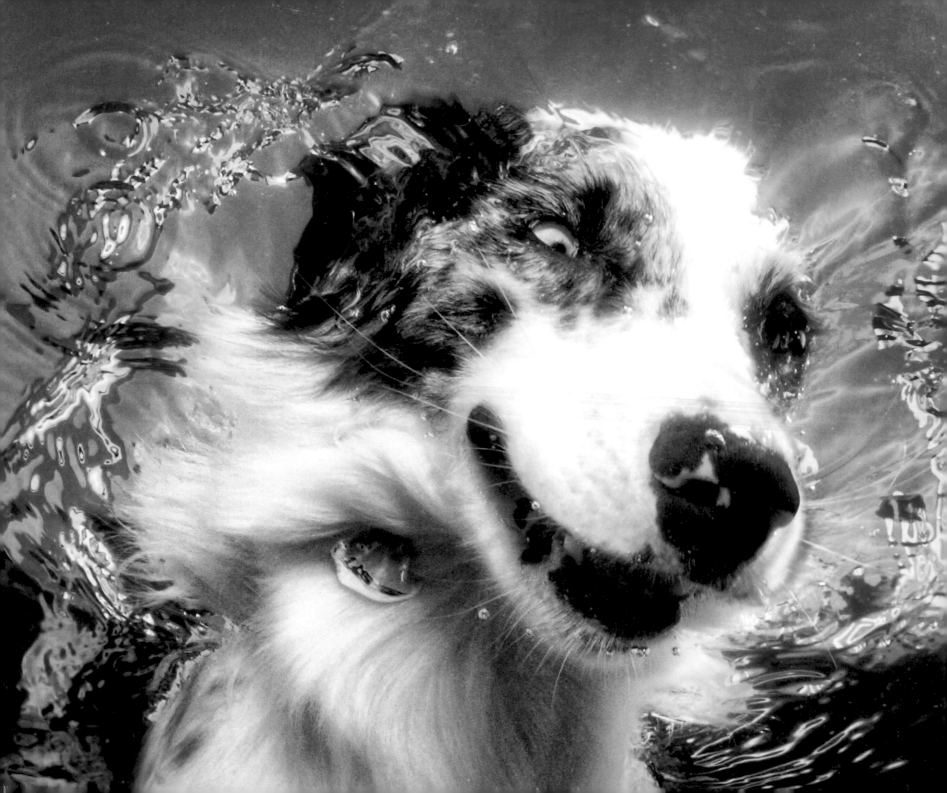

Banshee
Border Collie, 1 year

Bear
English Goldendoodle, 8 months

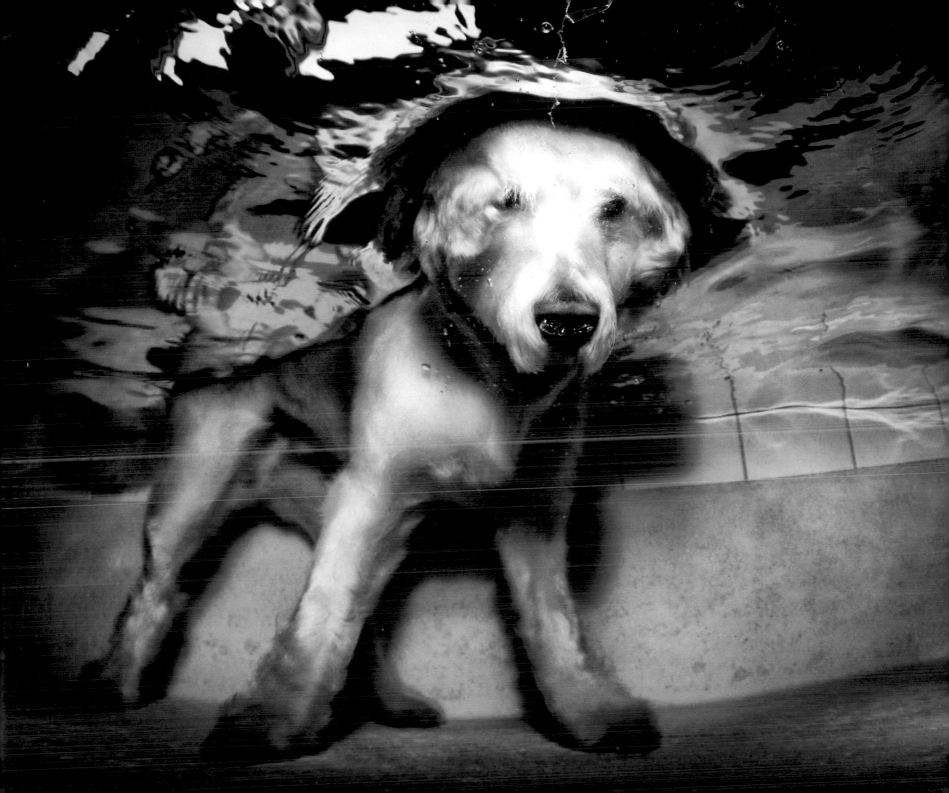

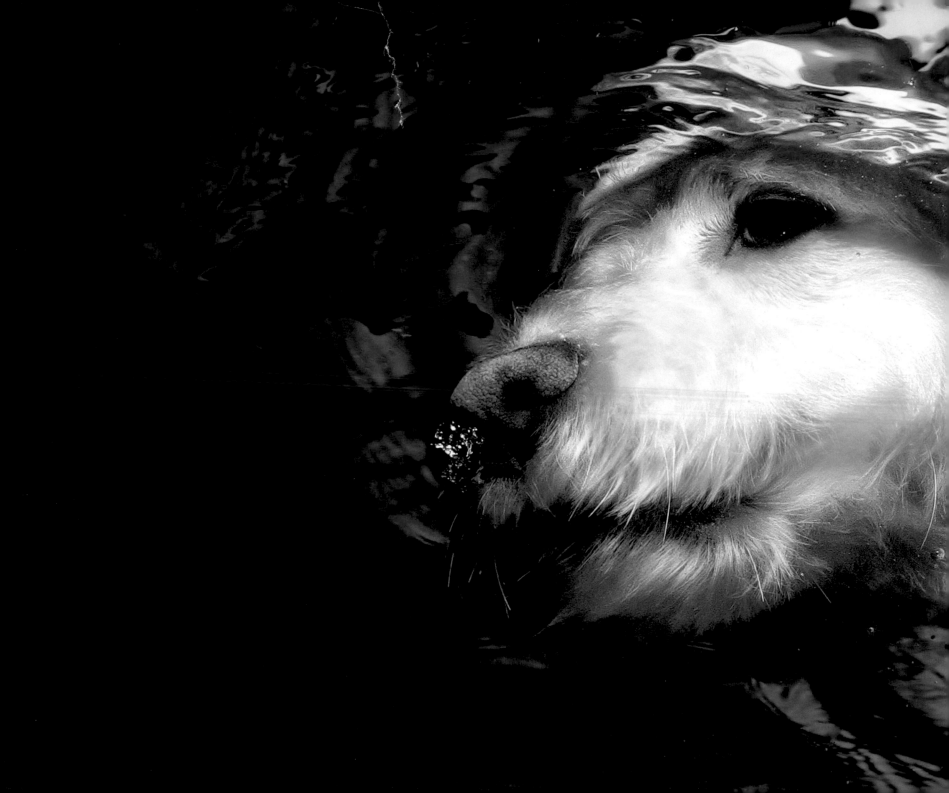

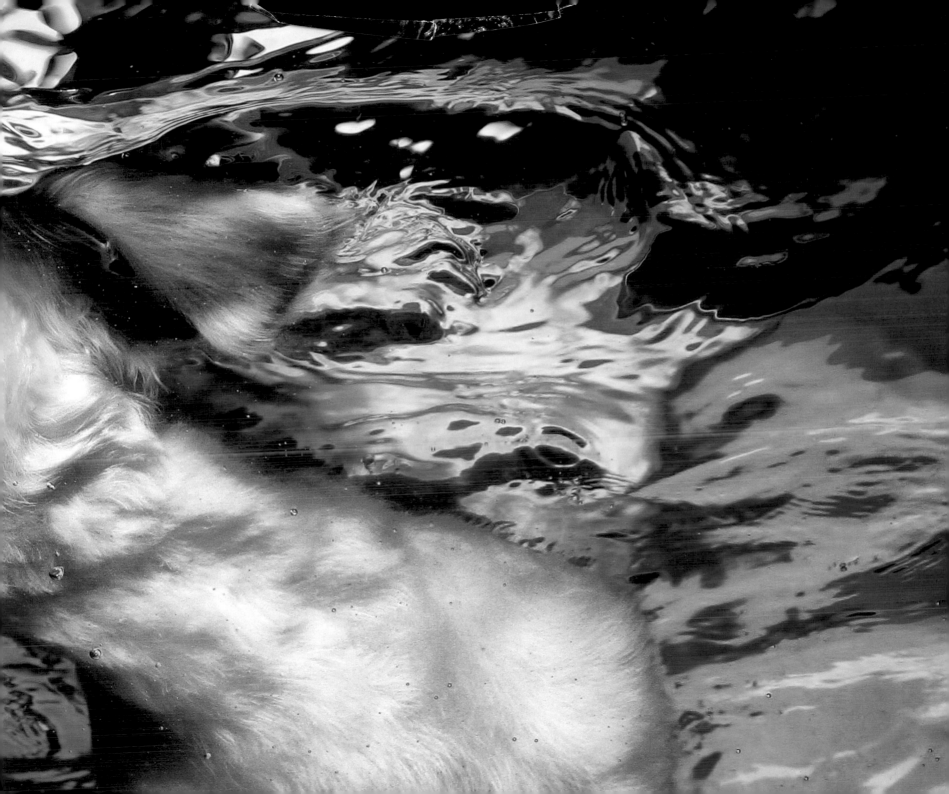

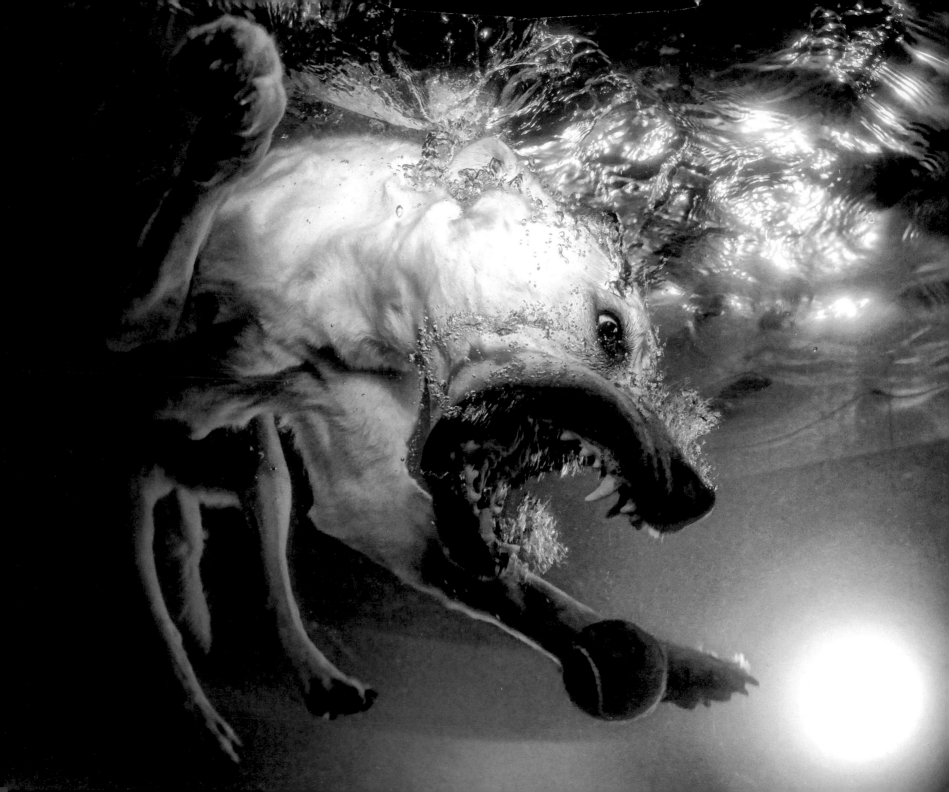

Alex
Labrador Retriever, 7 years

Bella
Weimaraner, 4 years

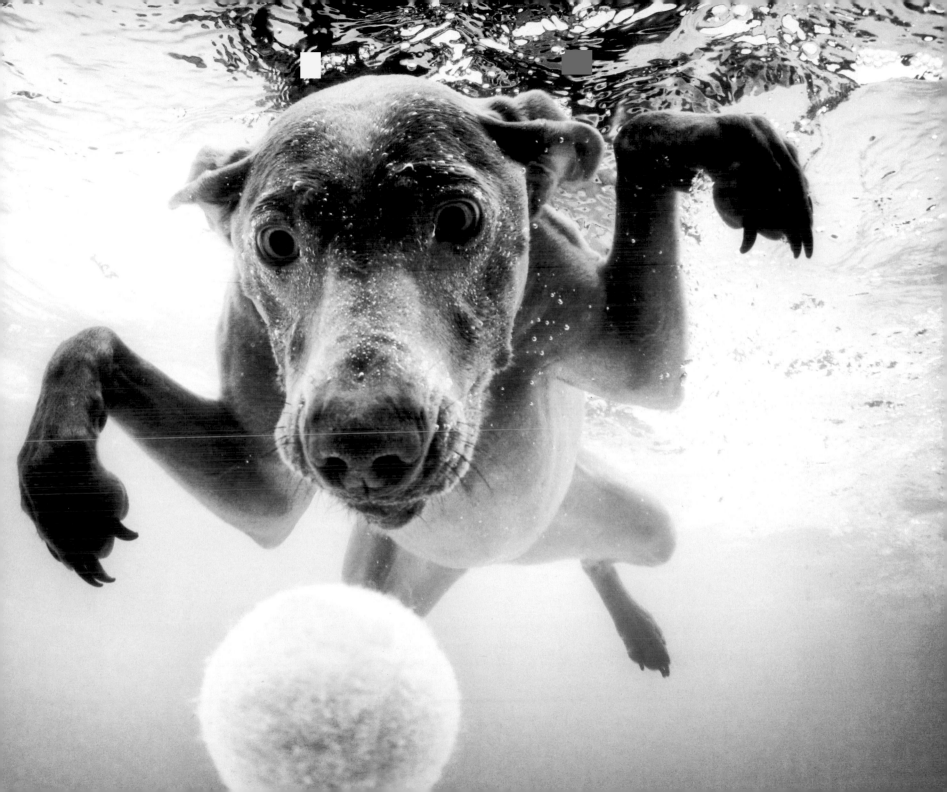

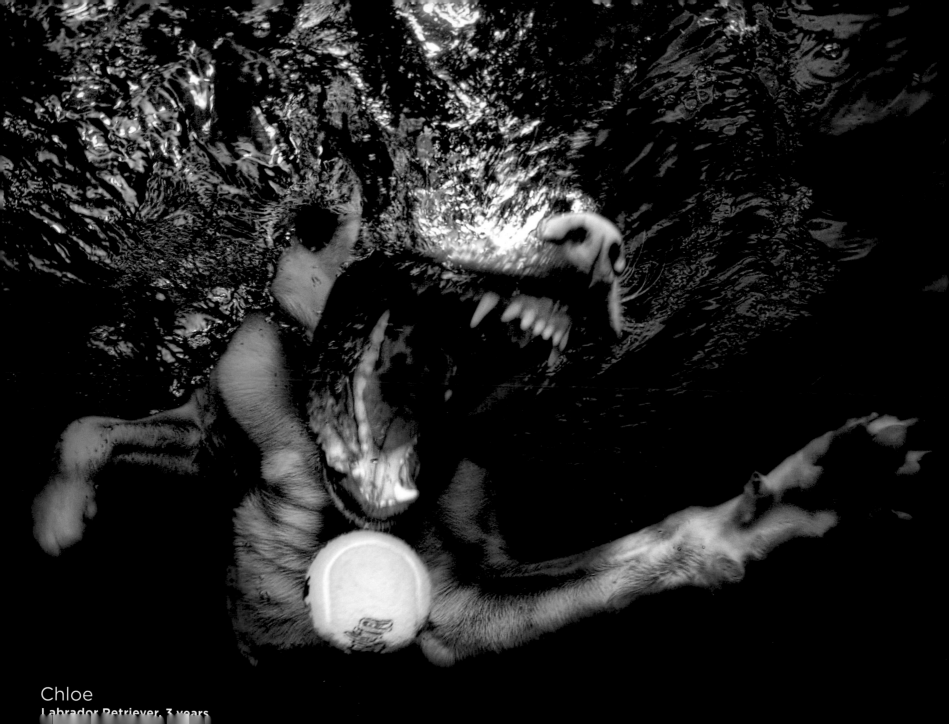

Chloe
Labrador Retriever, 3 years

Remi
Labrador Retriever, 5 years

Ben
Golden Retriever, 13 years

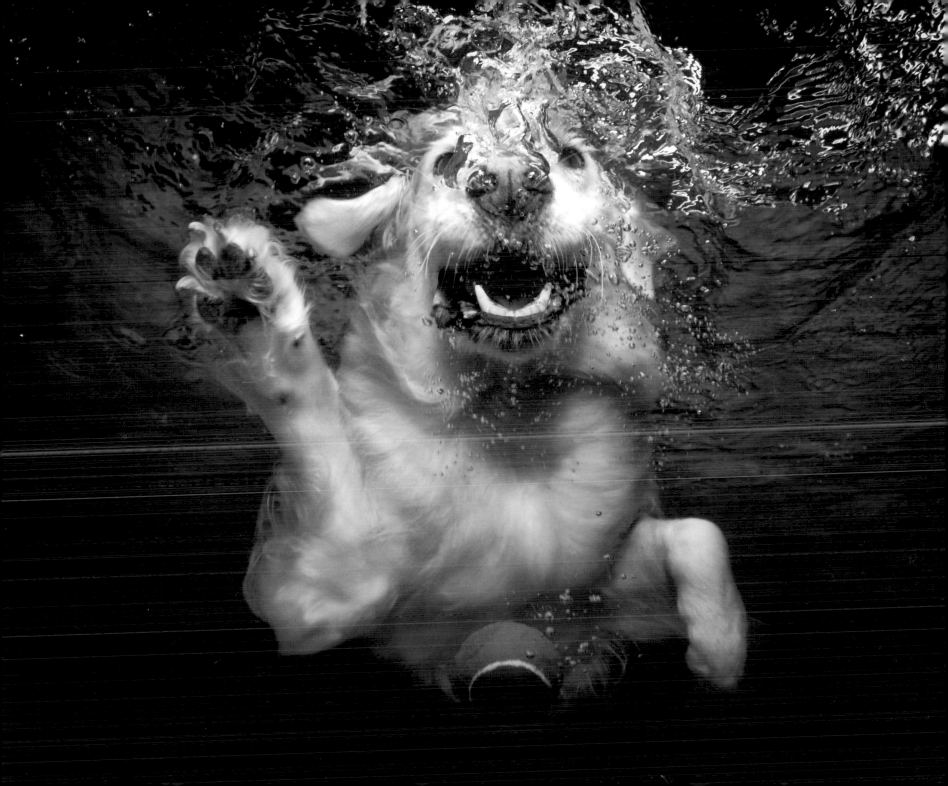

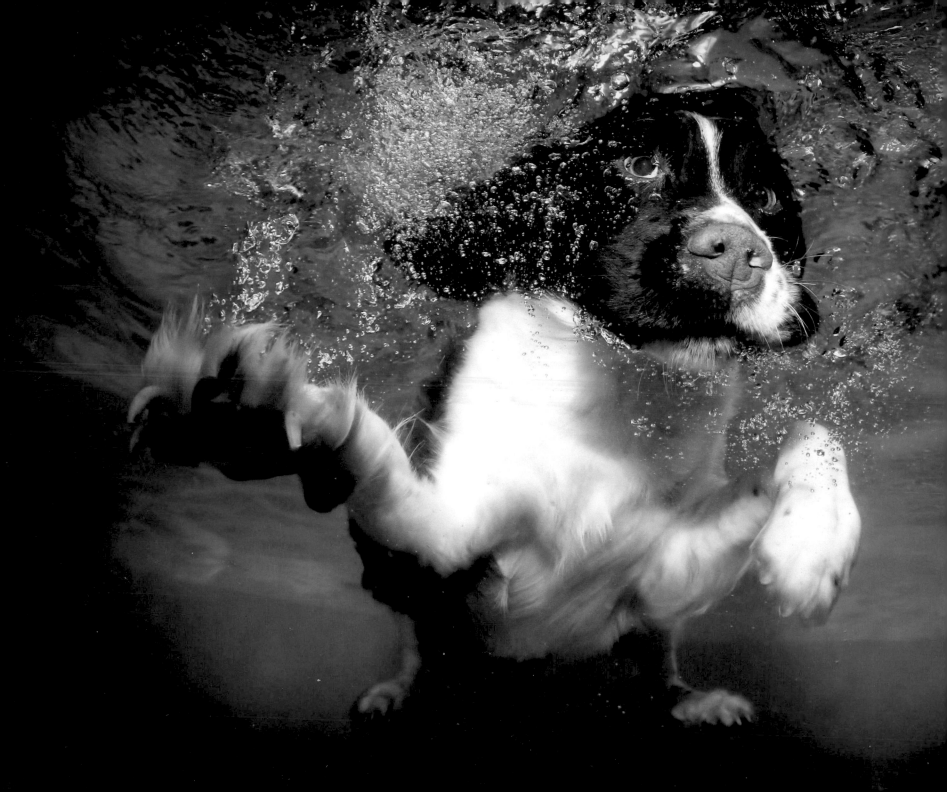

Birdie
English Springer Spaniel, 4 years

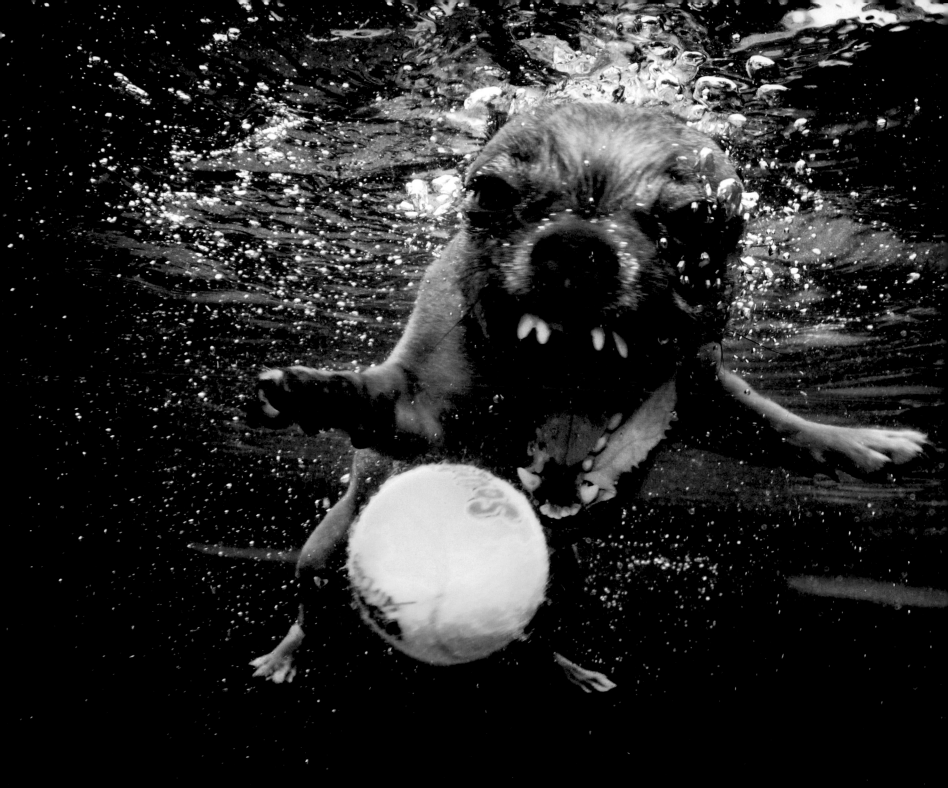

Bella
Chihuahua, 8 years

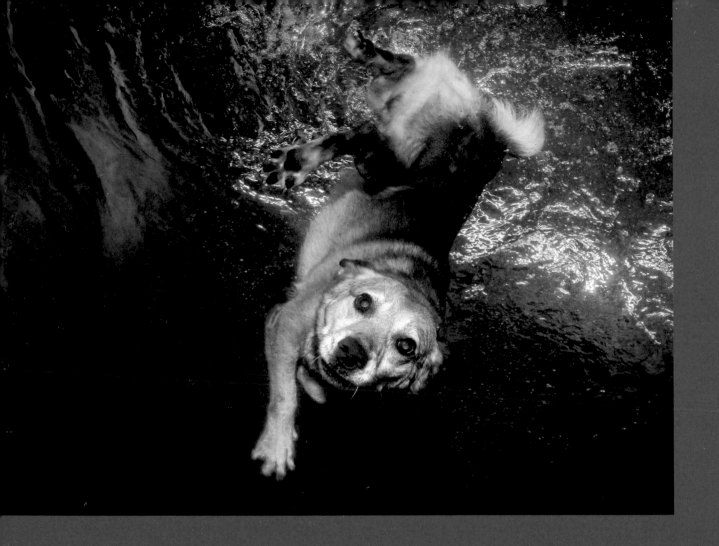

Bob
Corgi Mix, 6 years

Raika
Belgian Tervuren, 8 years

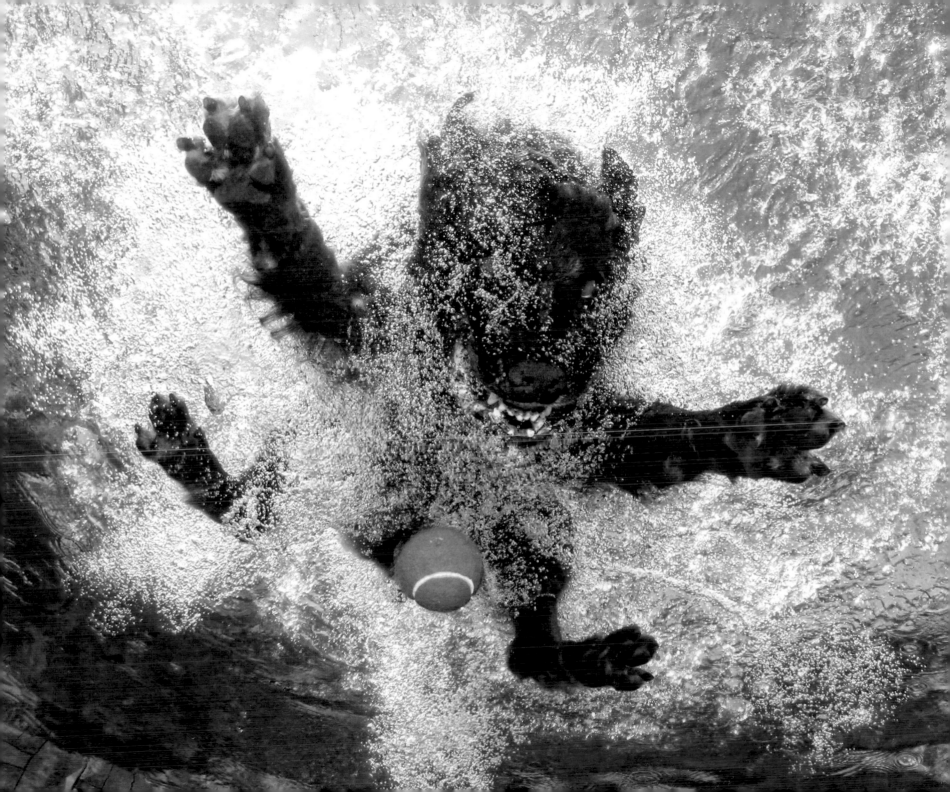

Brady
Yorkshire Terrier, 3 years

Duncan
Pug, 5 years

Bristles
Newfoundland, 7 years

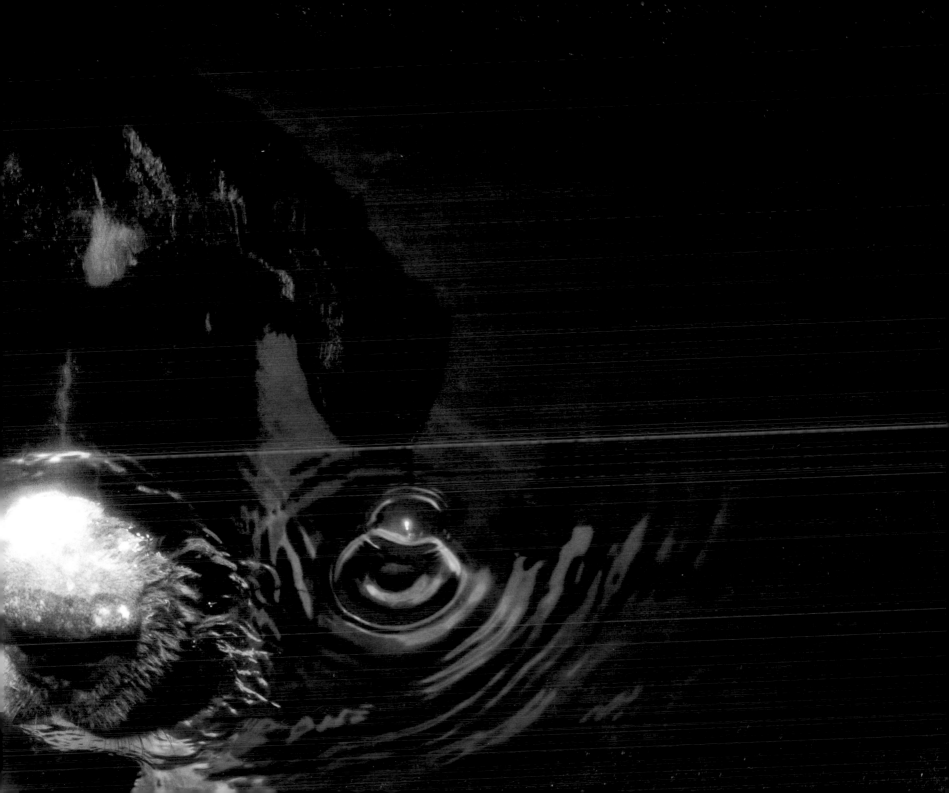

Charlie
Black Labrador Retriever, 9 years

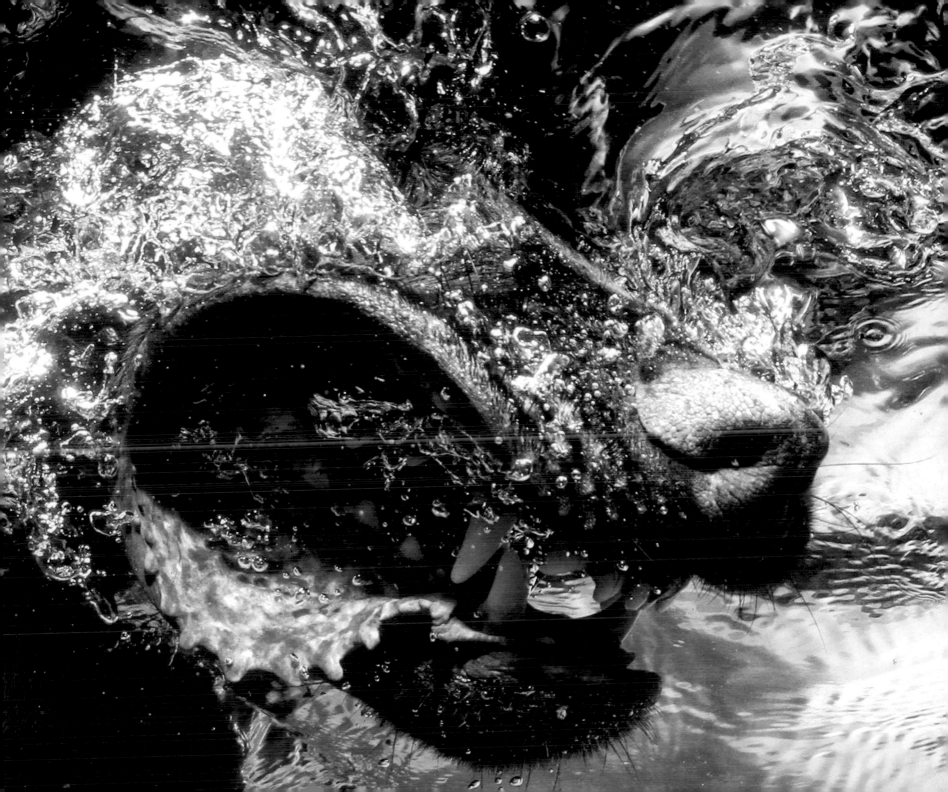

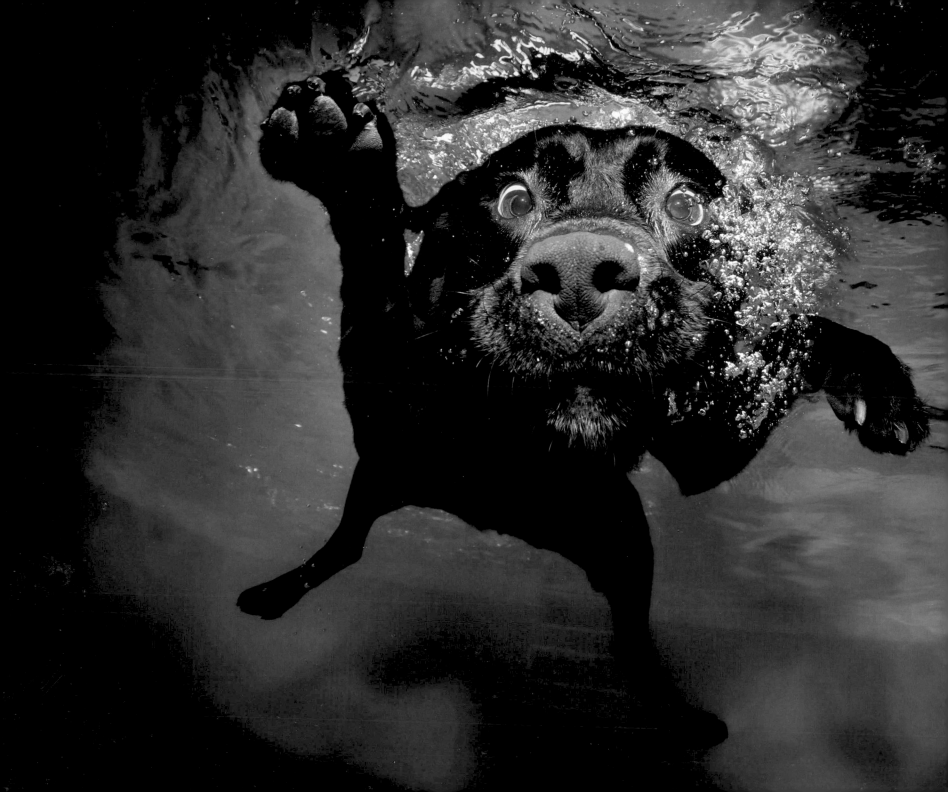

Duchess
Black Labrador Retriever, 5 years

Dooley
Labrador Retriever, 3 years

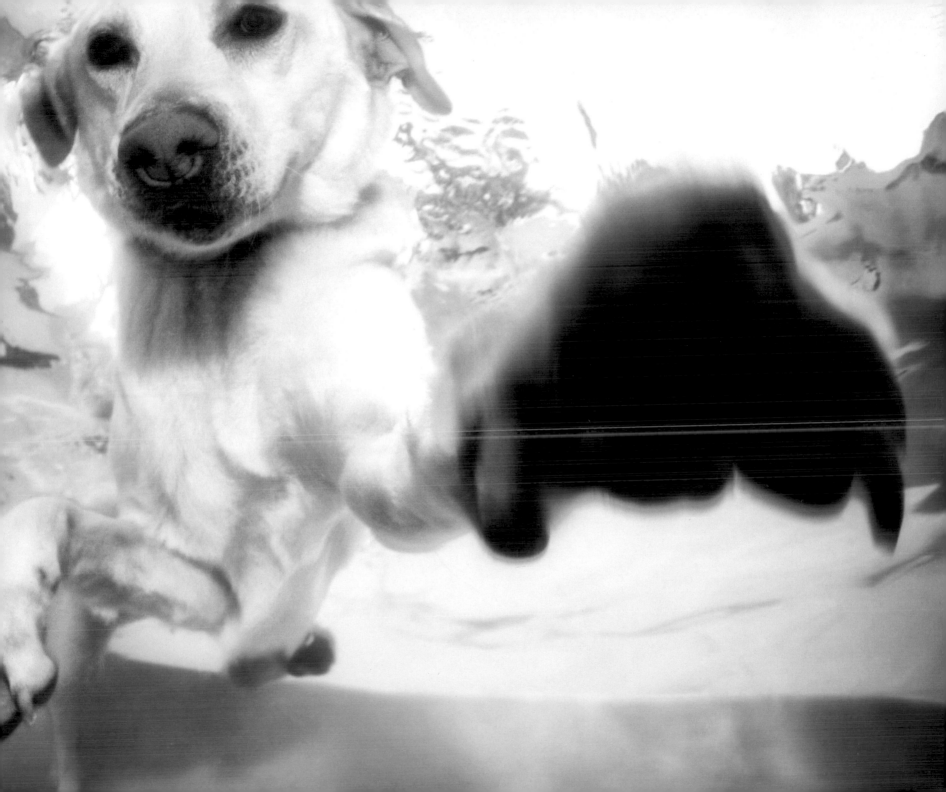

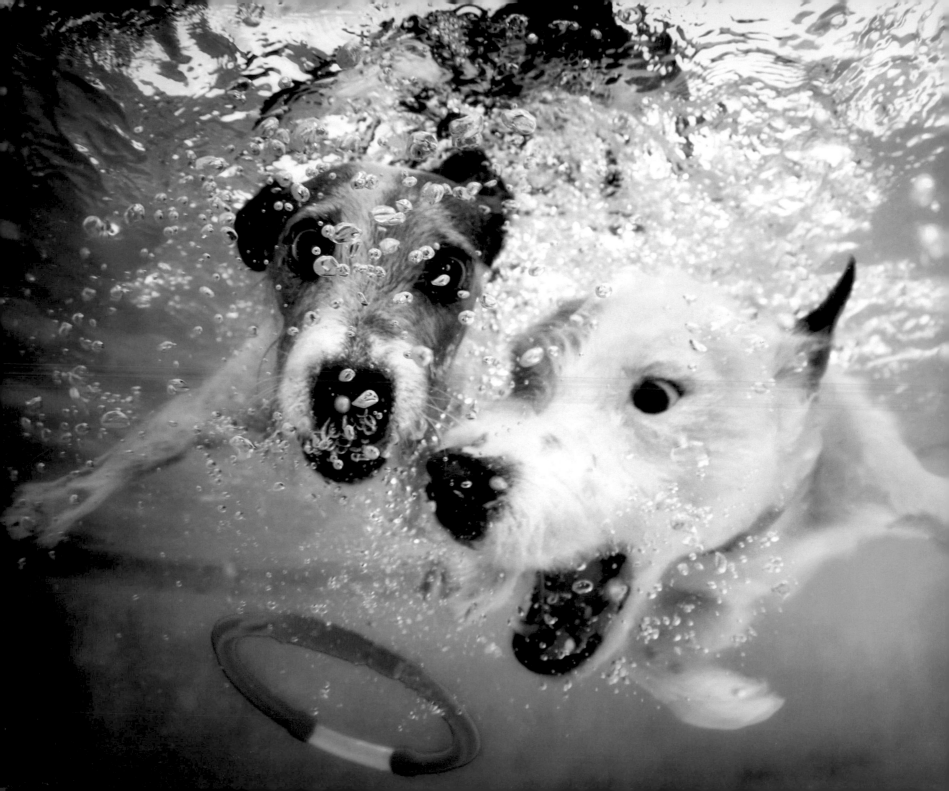

Duke (with Lulu)
Jack Russell Terrier, 4 years

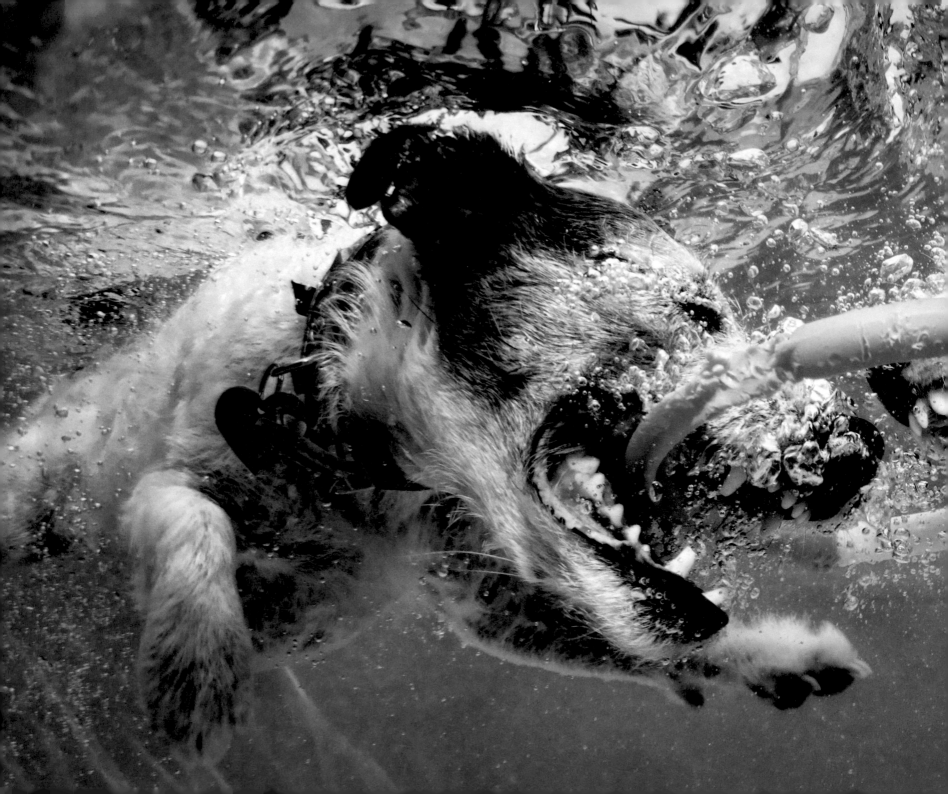

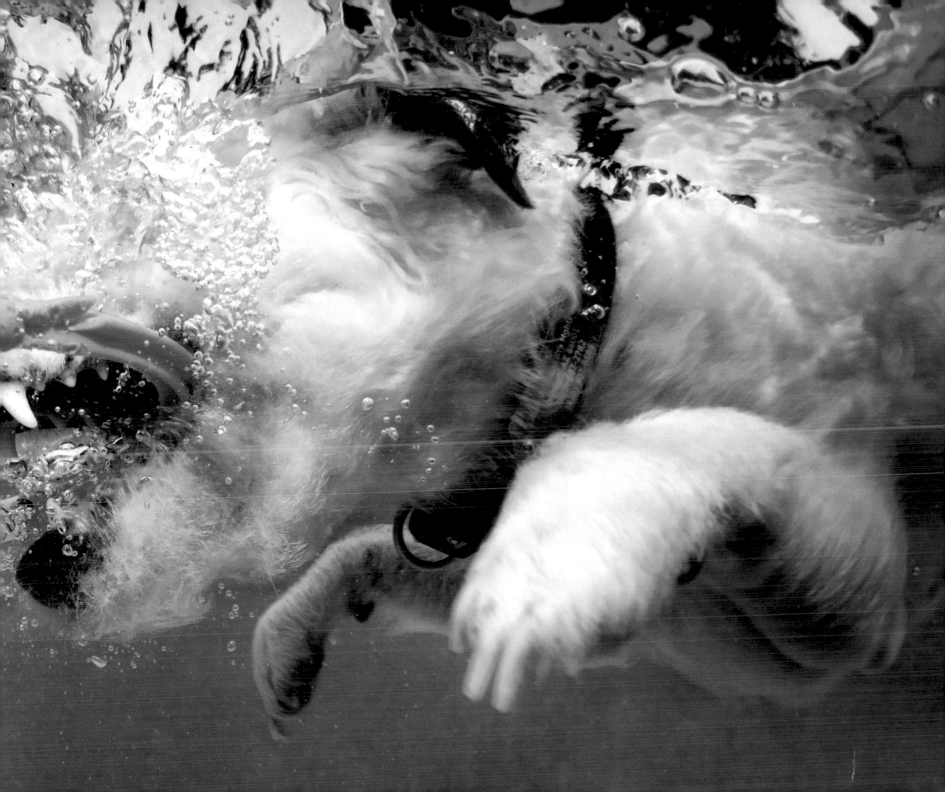

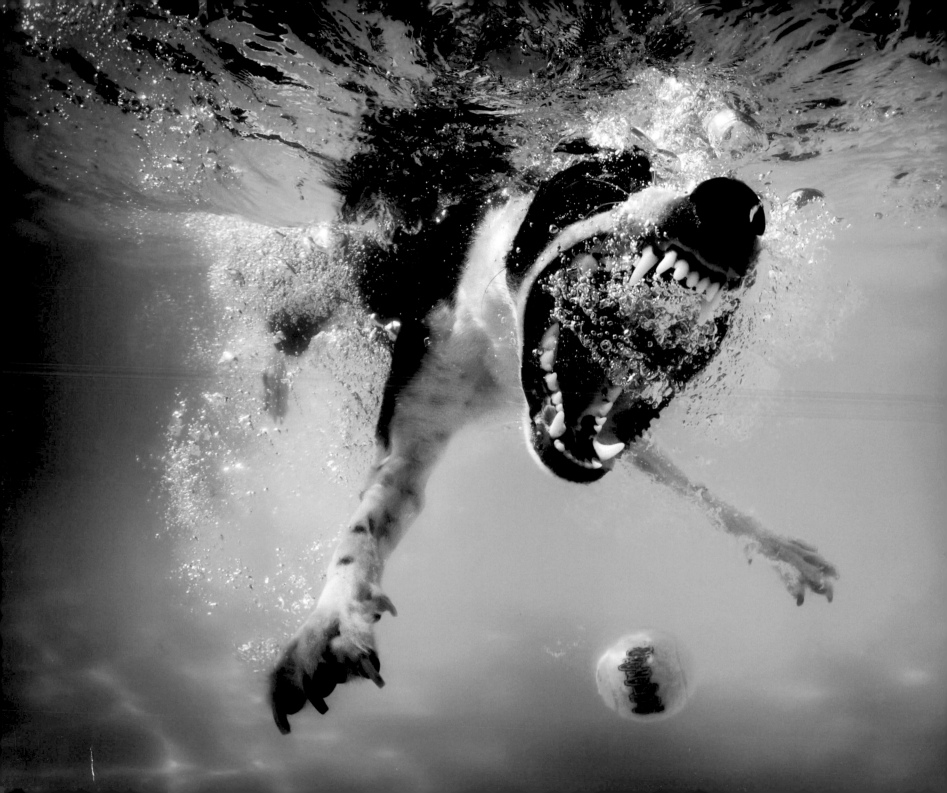

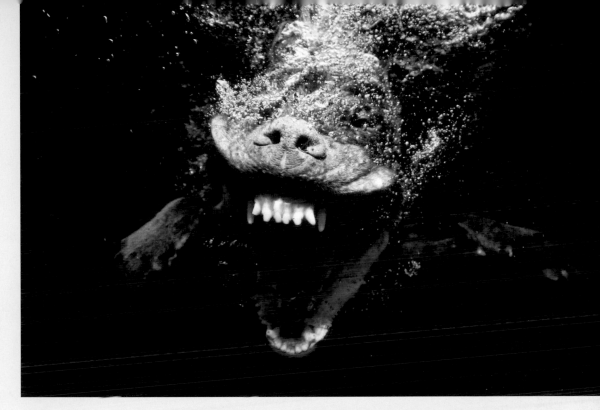

Stanley
Chesapeake Bay Retriever, 8 years

Fleet
Border Collie-Kelpie-Whippet Mix, 2 years

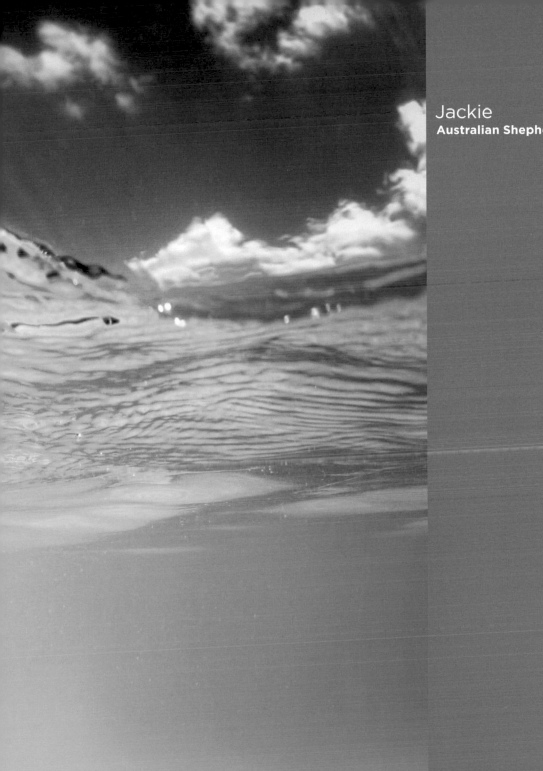

Jackie
Australian Shepherd Mix, 5 years

Gunner
Yellow Labrador Retriever, 2 years

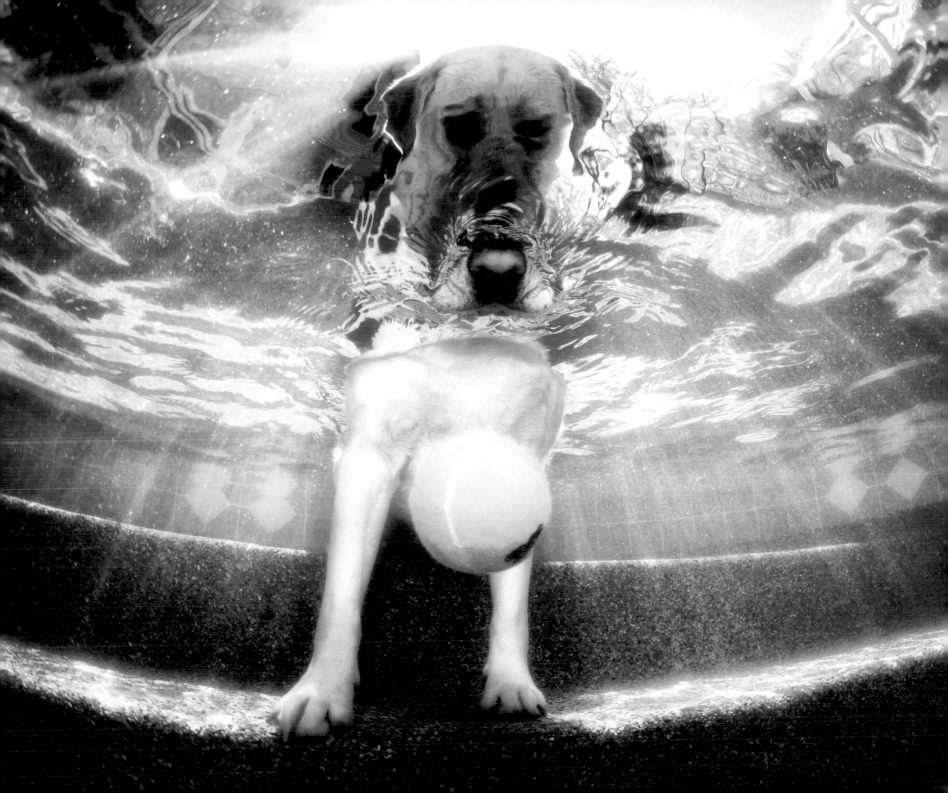

Foster
Dachshund, 6 years

Mr. Beefy
Olde English Bulldogge, 6 years

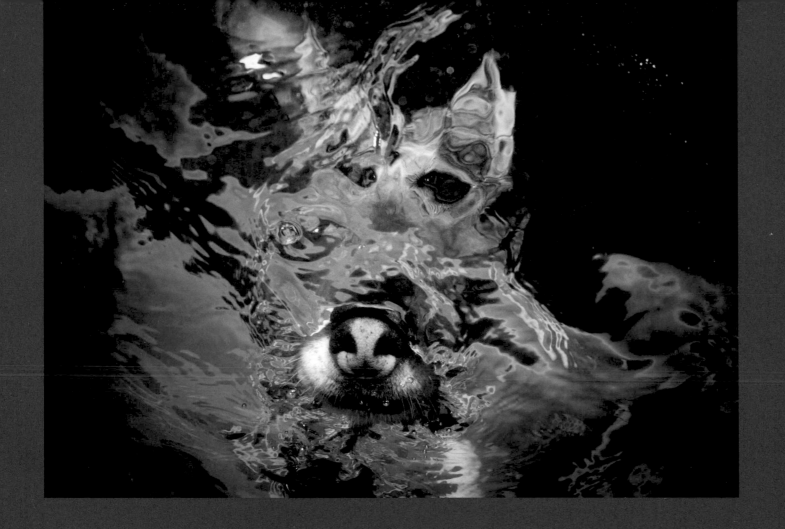

Grayson
Wolf-Husky Mix, 7–10 years

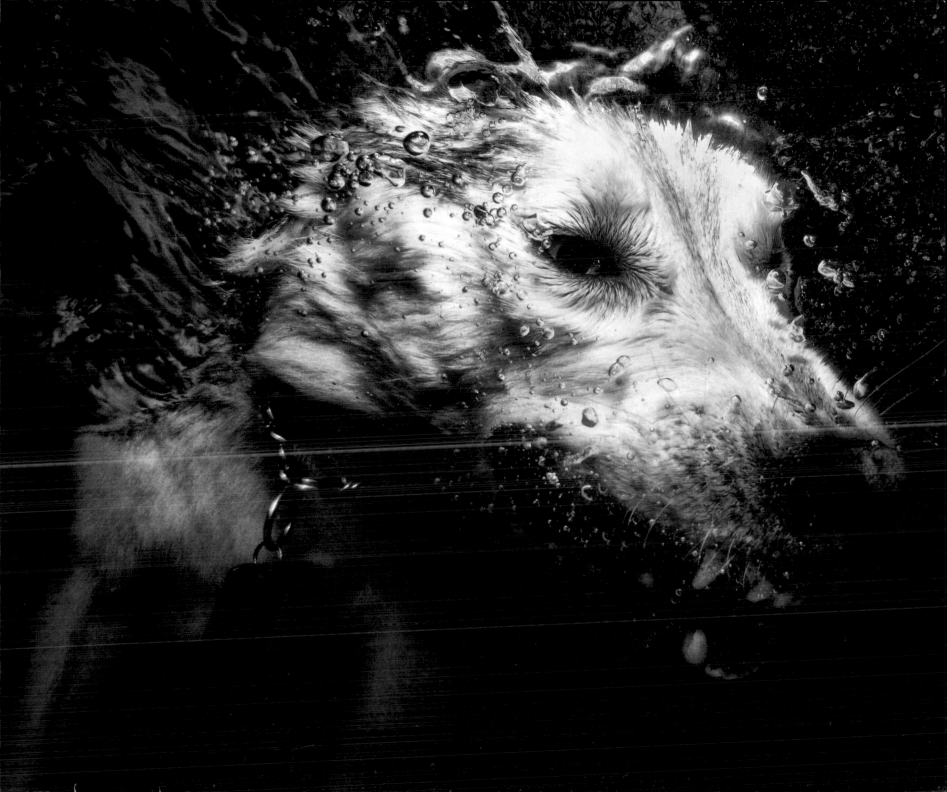

Jigger
Border Collie, 2 years

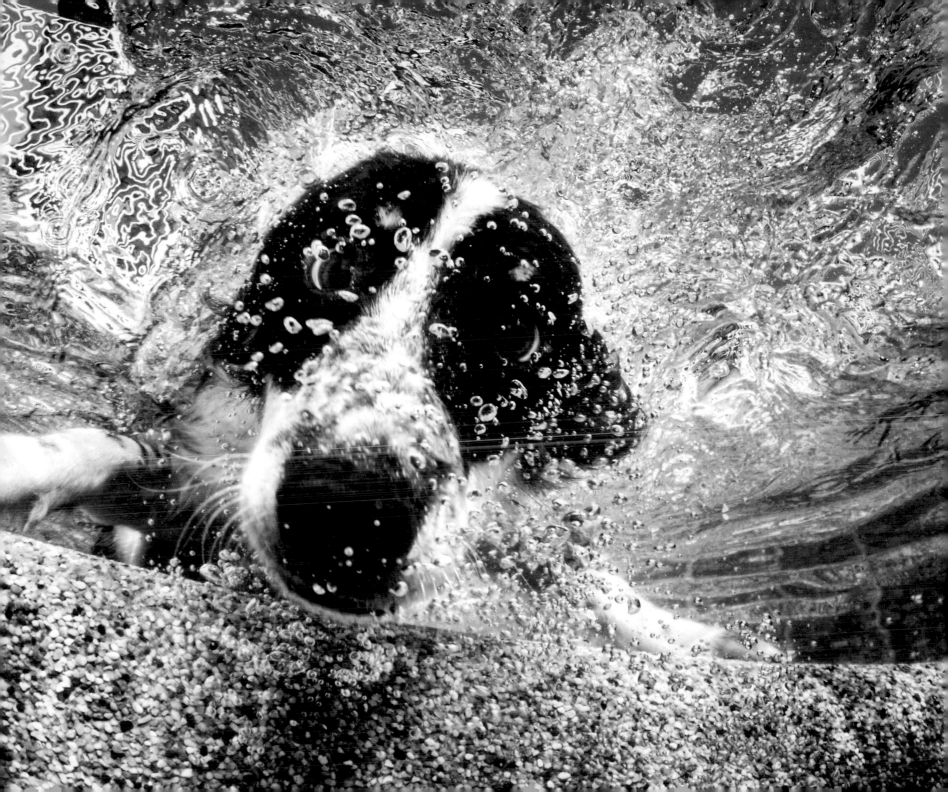

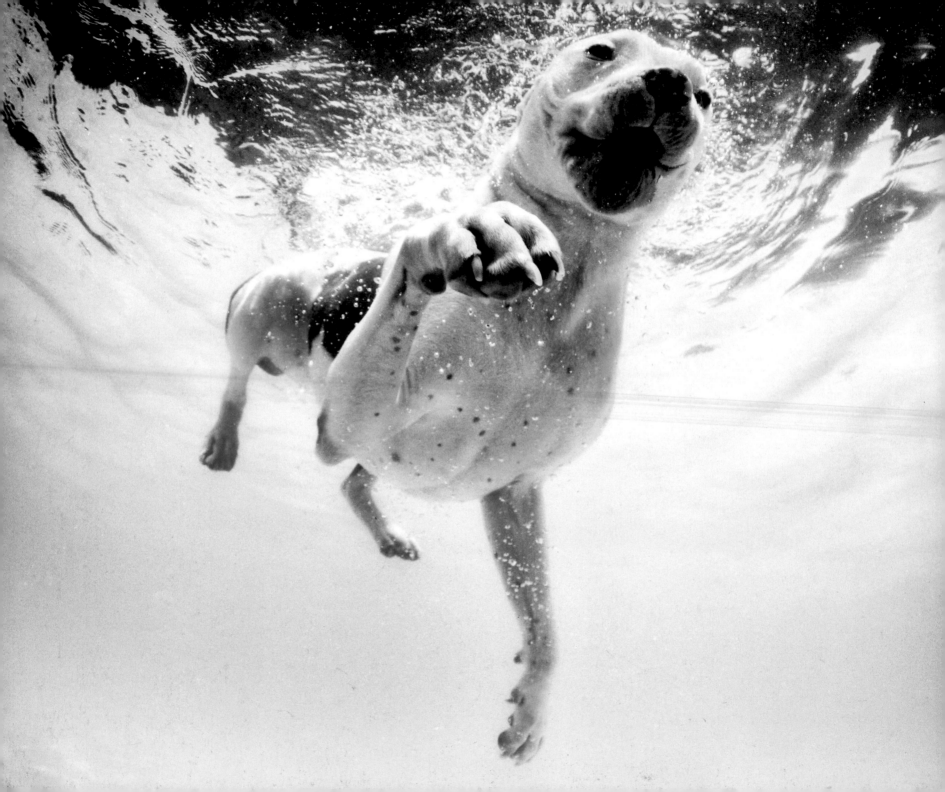

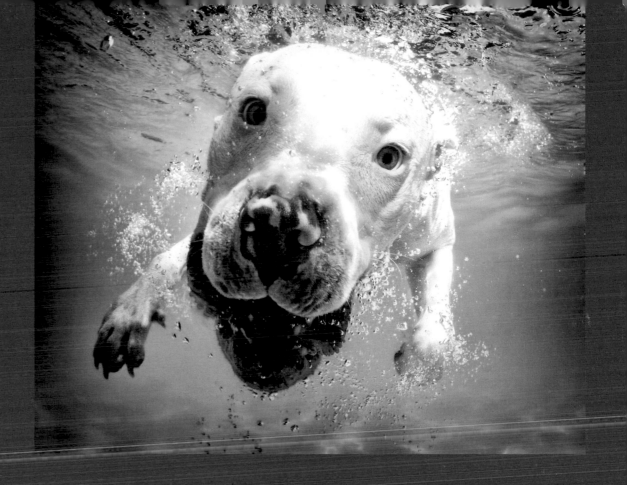

Jake
American Pit Bull Terrier Mix, 2 years

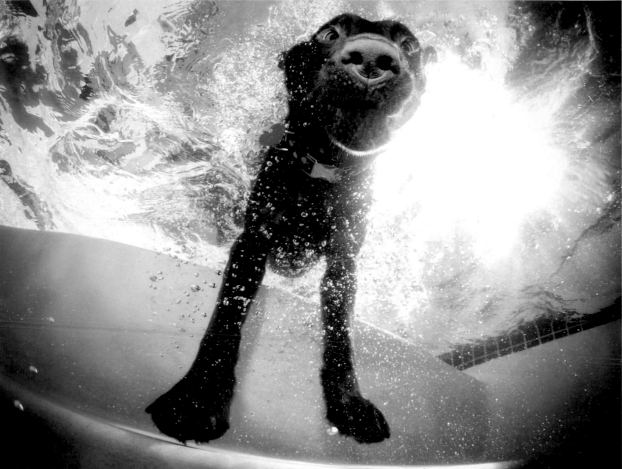

Kona
Chocolate Labrador Retriever, 1.5 years

King
Yellow Labrador Retriever, 4 years

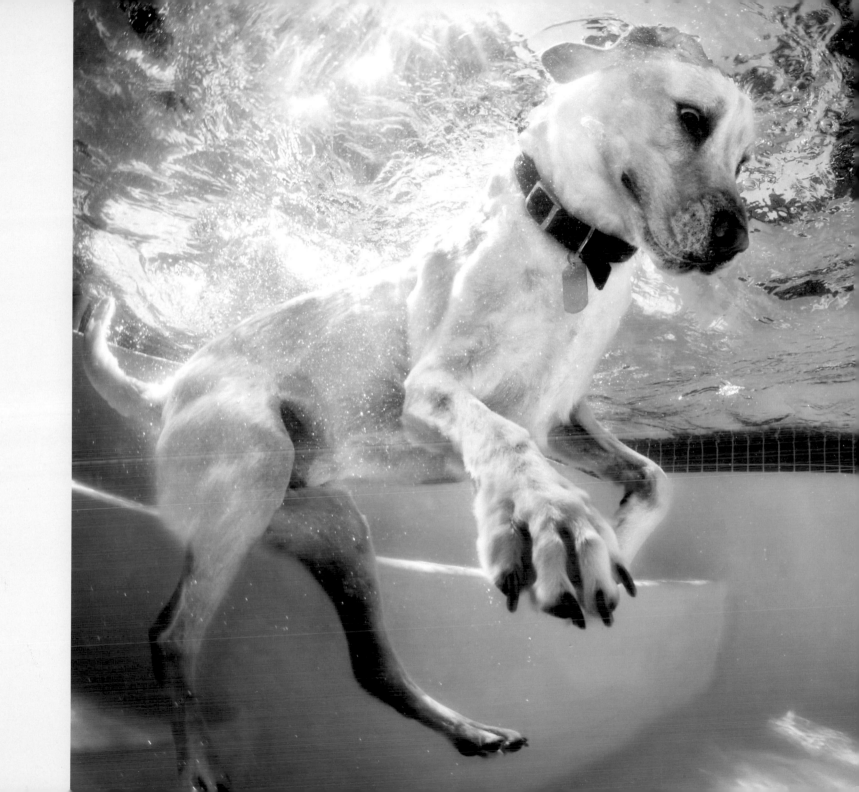

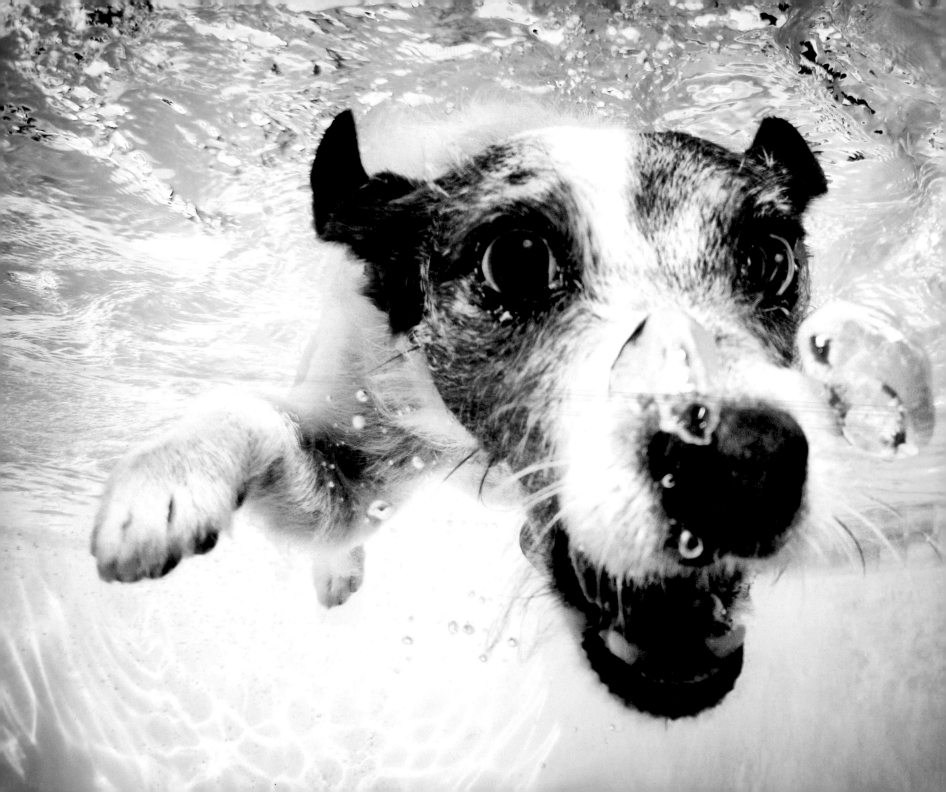

Lulu
Jack Russell Terrier, 5 years

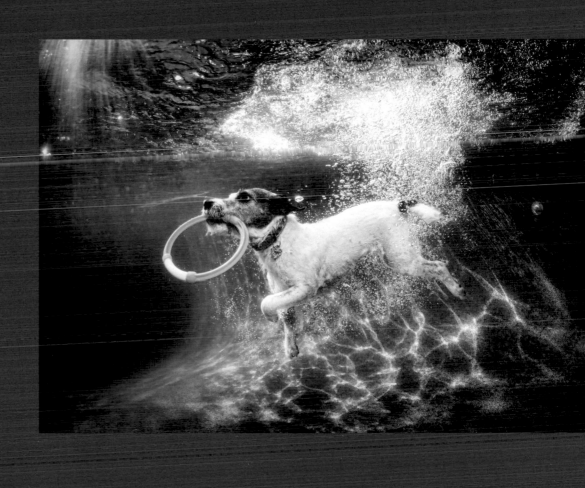

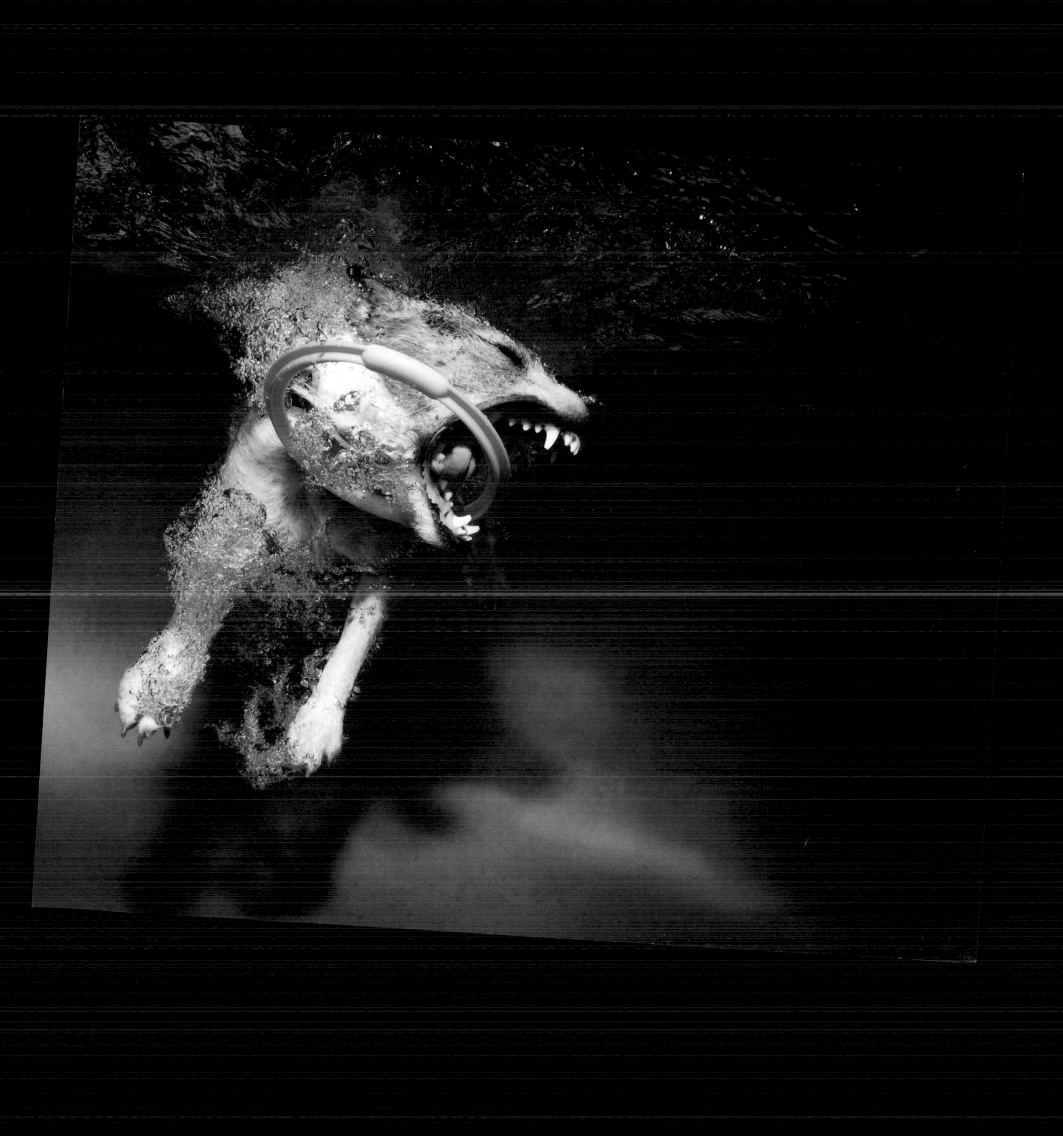

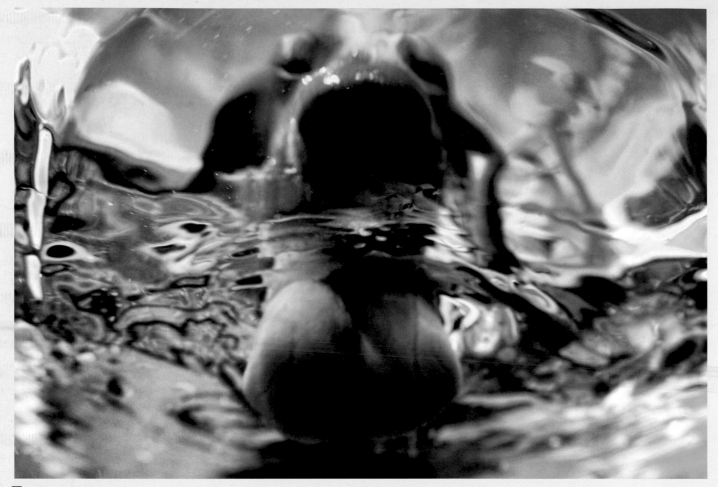

Tag
Dachshund, 6 years

Mugsy
English Bulldog, 8 years

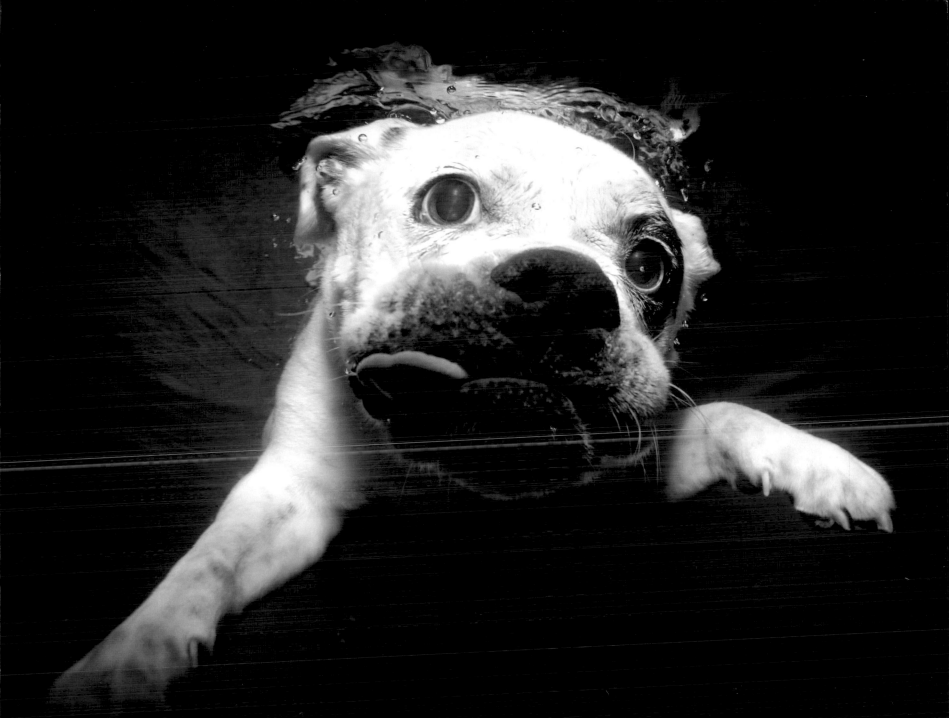

Mylo
Rottweiler, 6 years

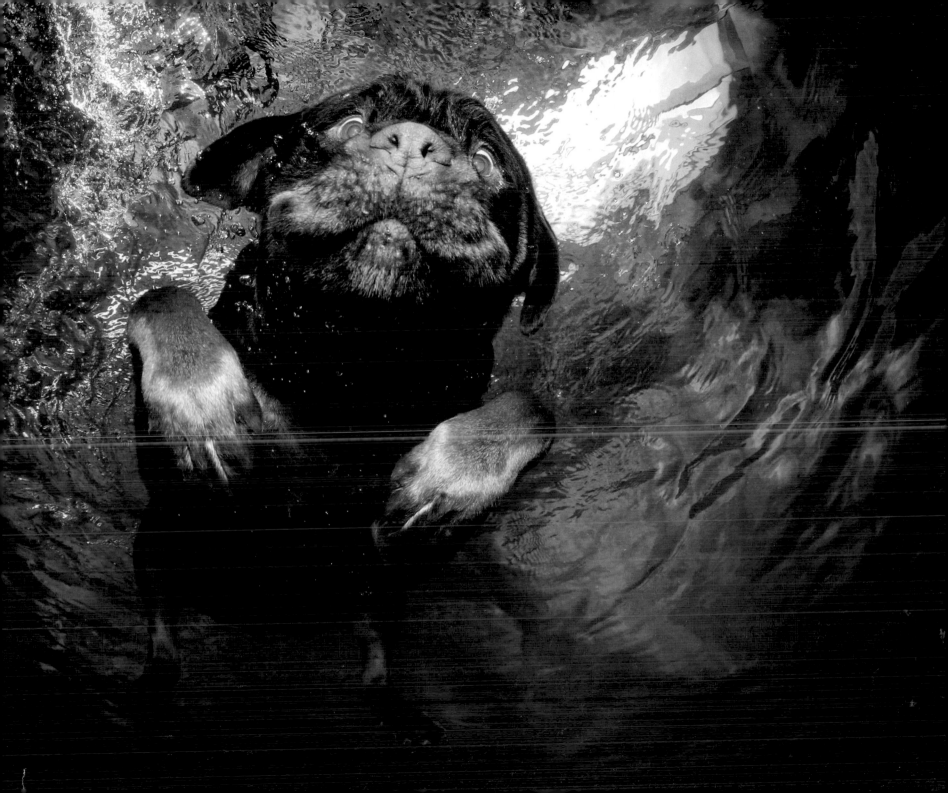

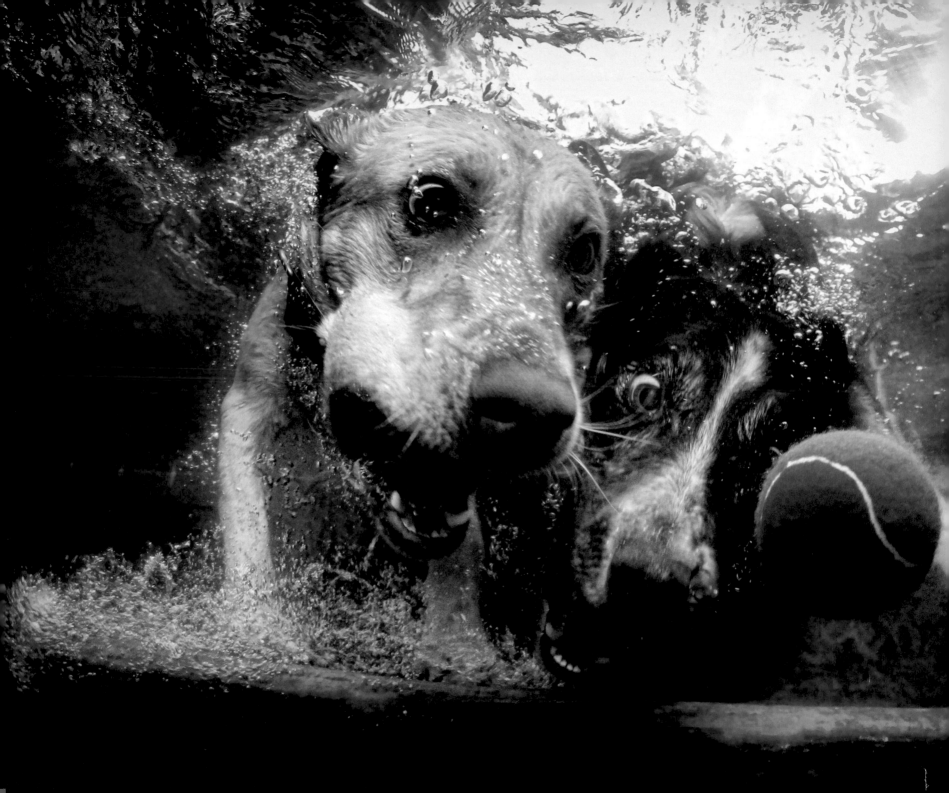

Nevada (with Bardot)
Border Collie, 7 years

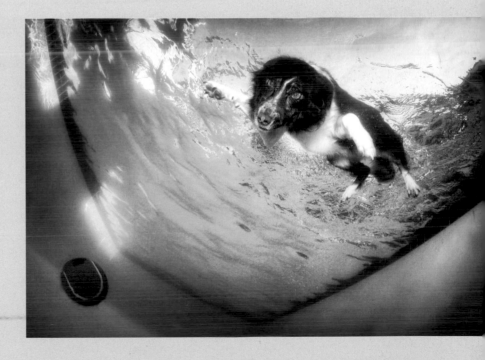

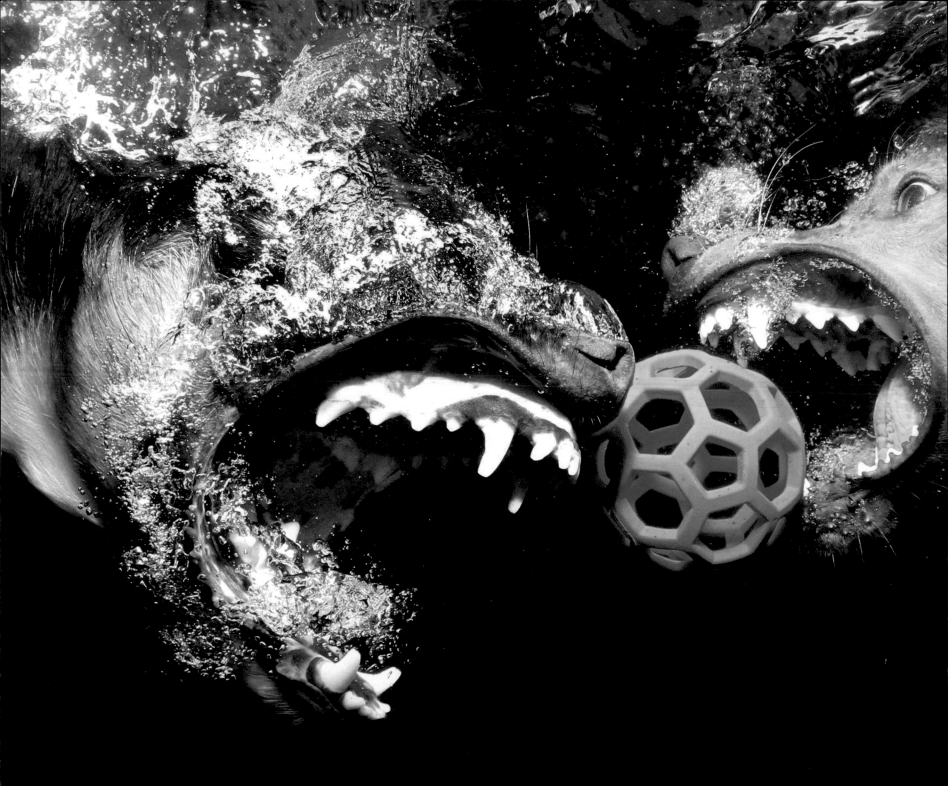

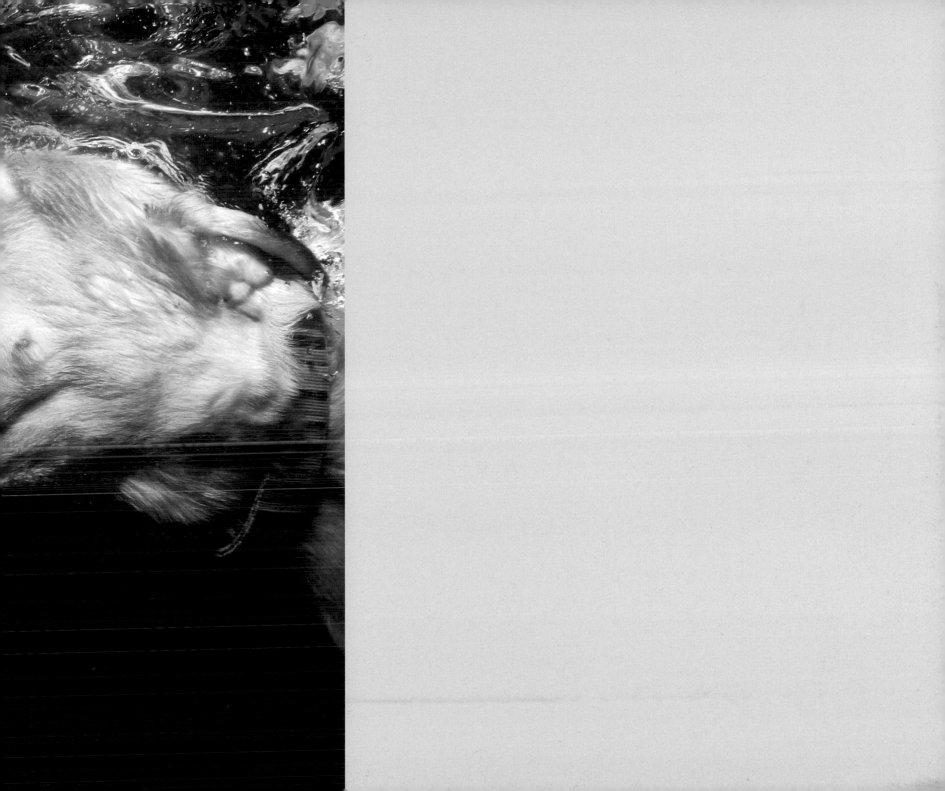

Nevada

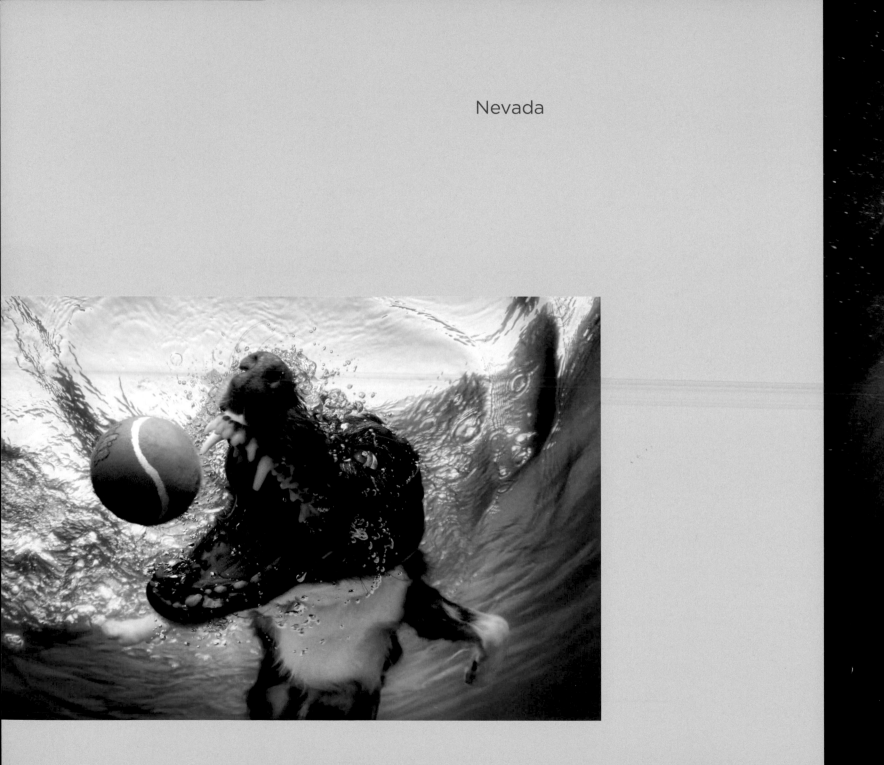

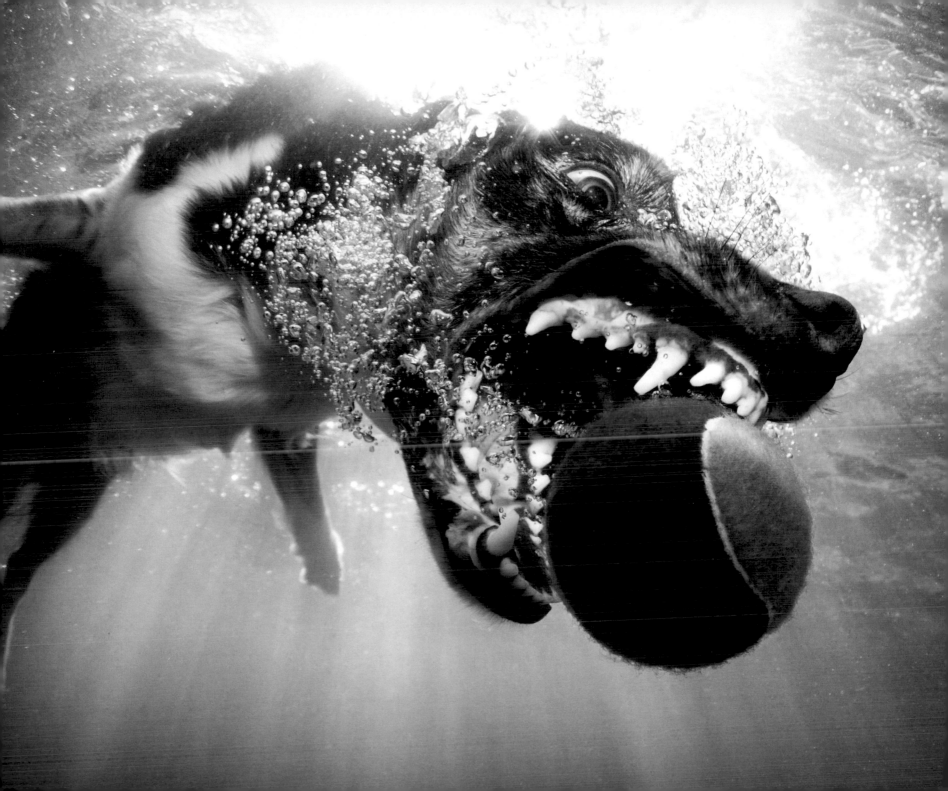

Ralphie
Chesapeake Bay Retriever, 5 years

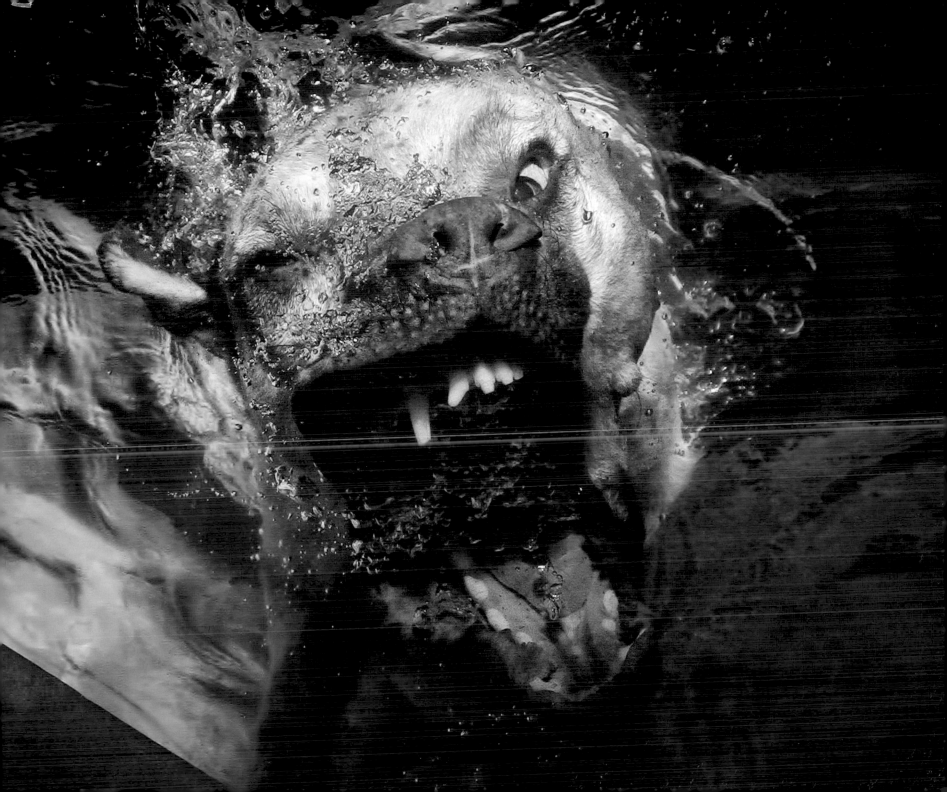

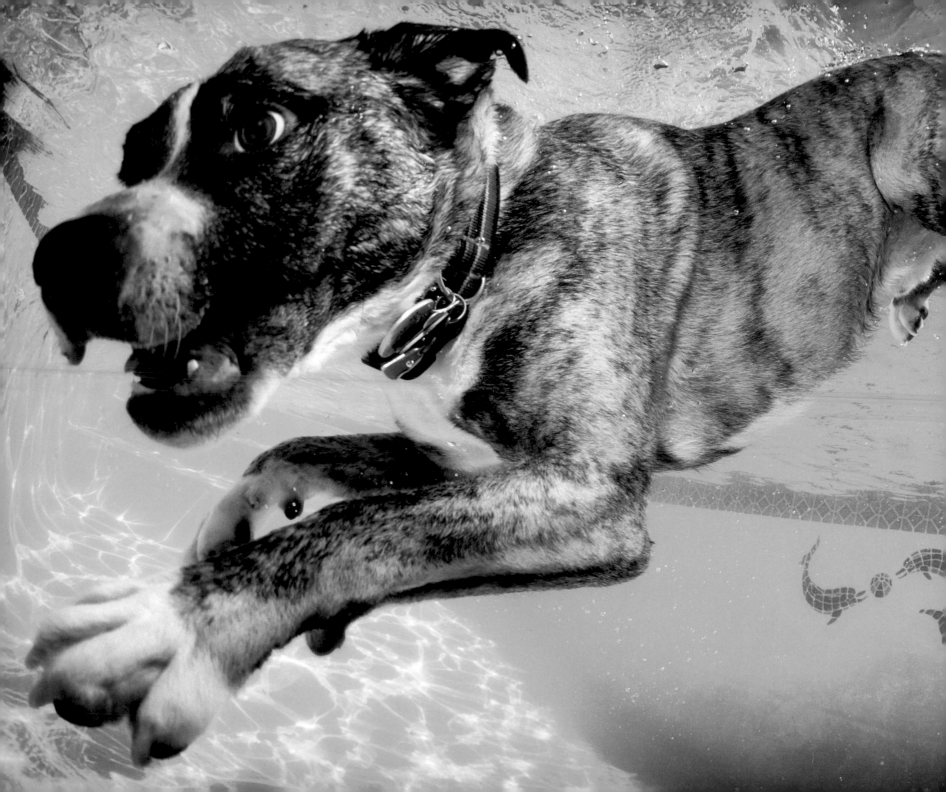

Wrigley
Boxer–Plott Hound Mix, 3 years

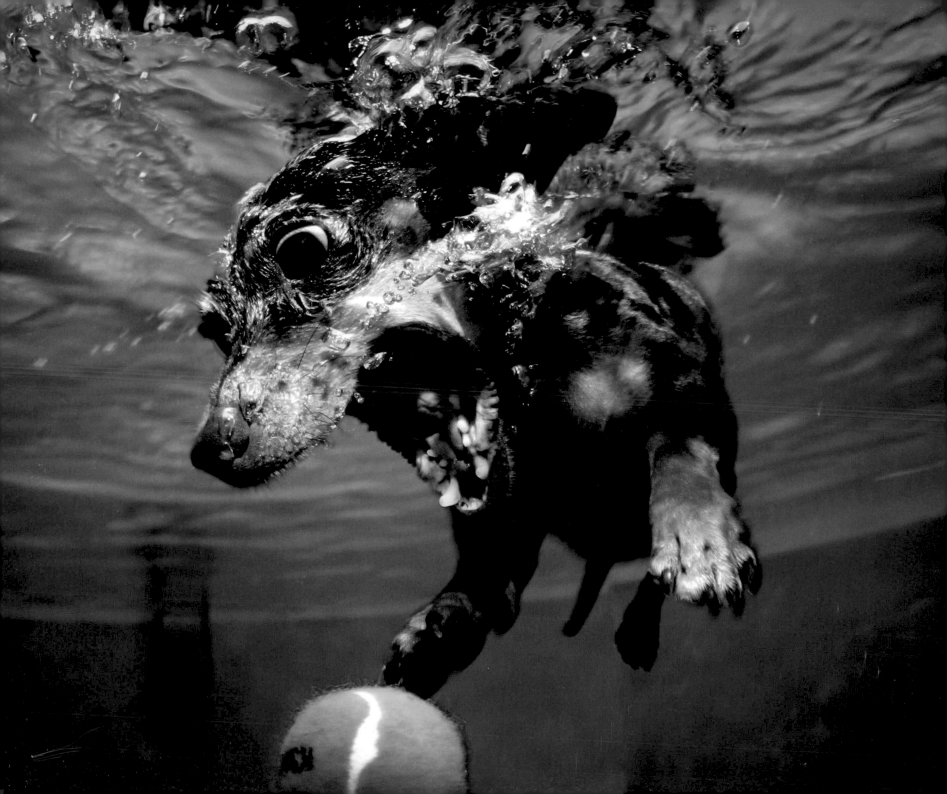

Rhoda
Dachshund, 7 years

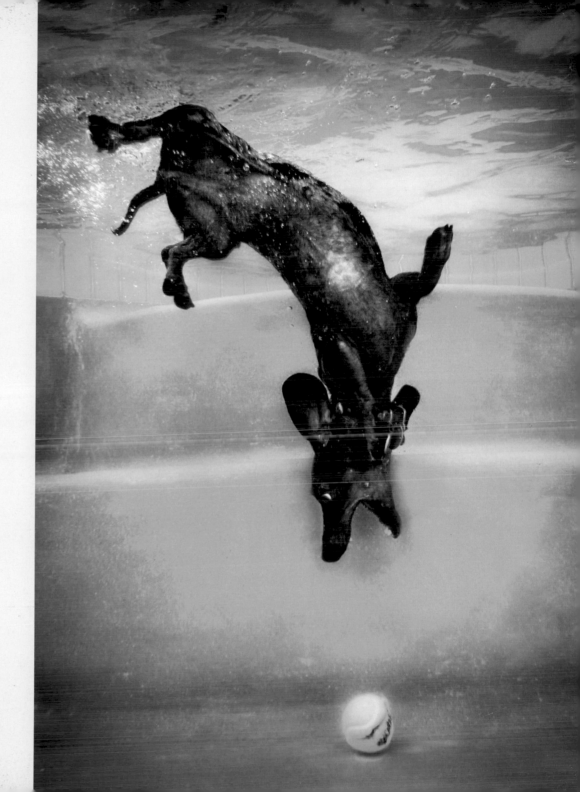

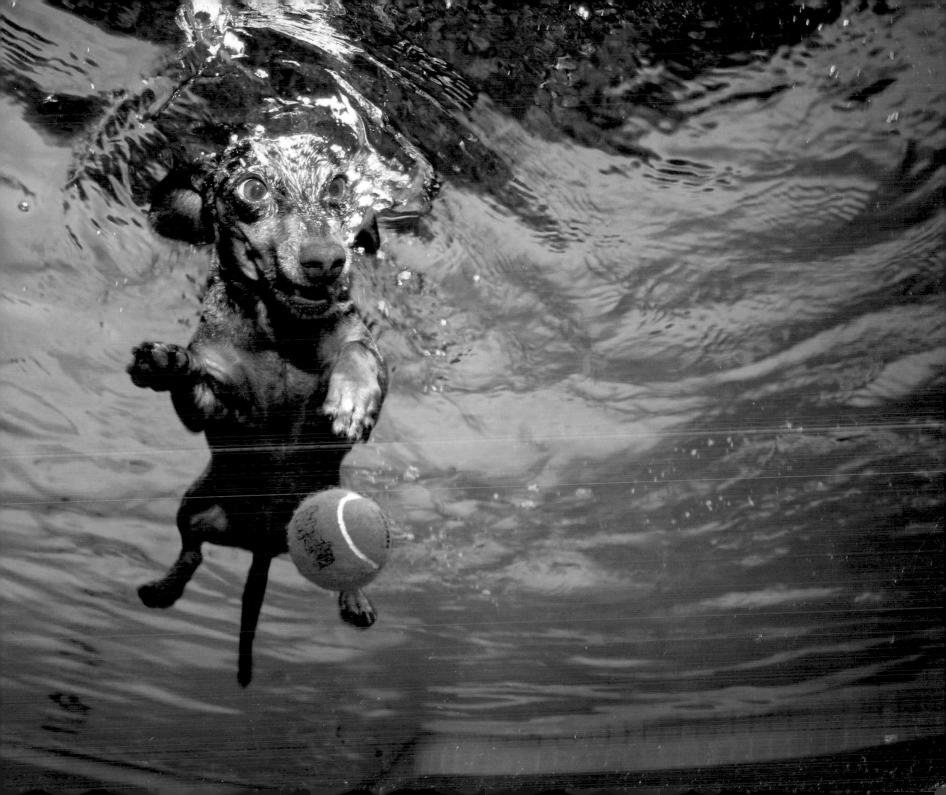

Tracer
Belgian Malinois, 4 years

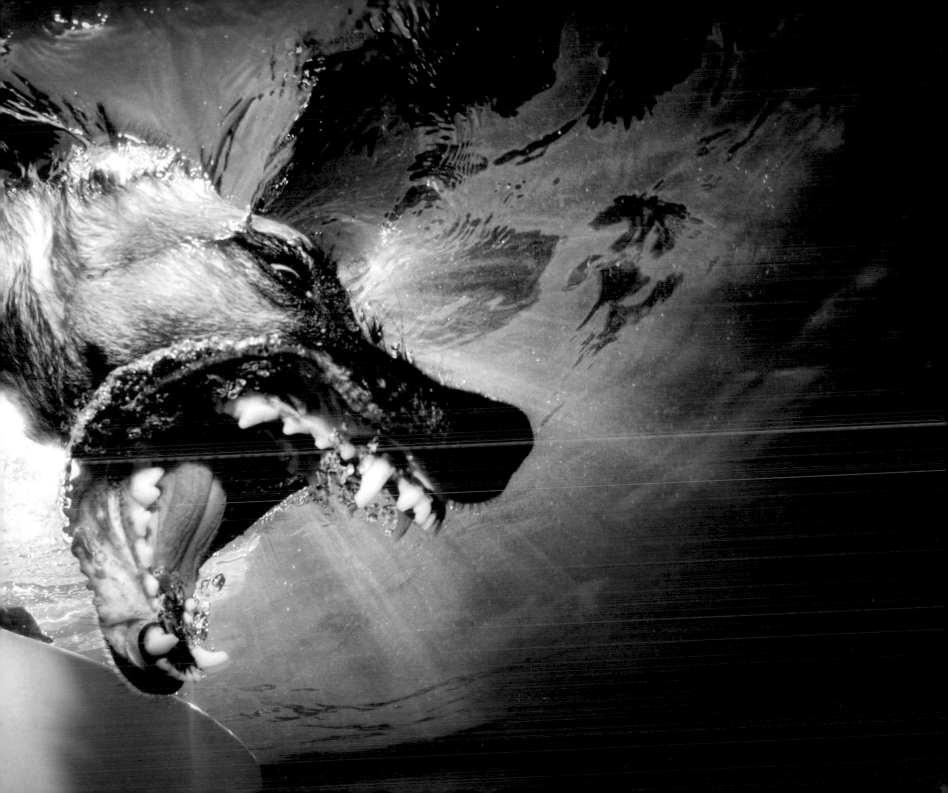

Rowdy
Golden Retriever, 3 years

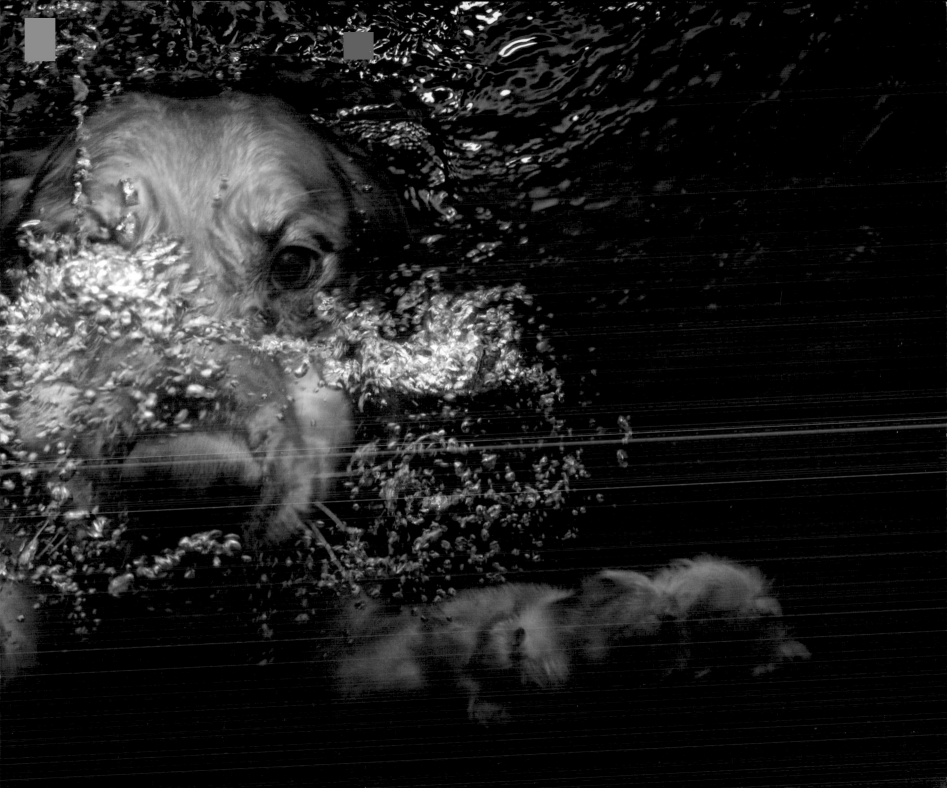

Victor
English Pointer, 3 years

Scout
Chocolate Labrador Retriever, 4 years

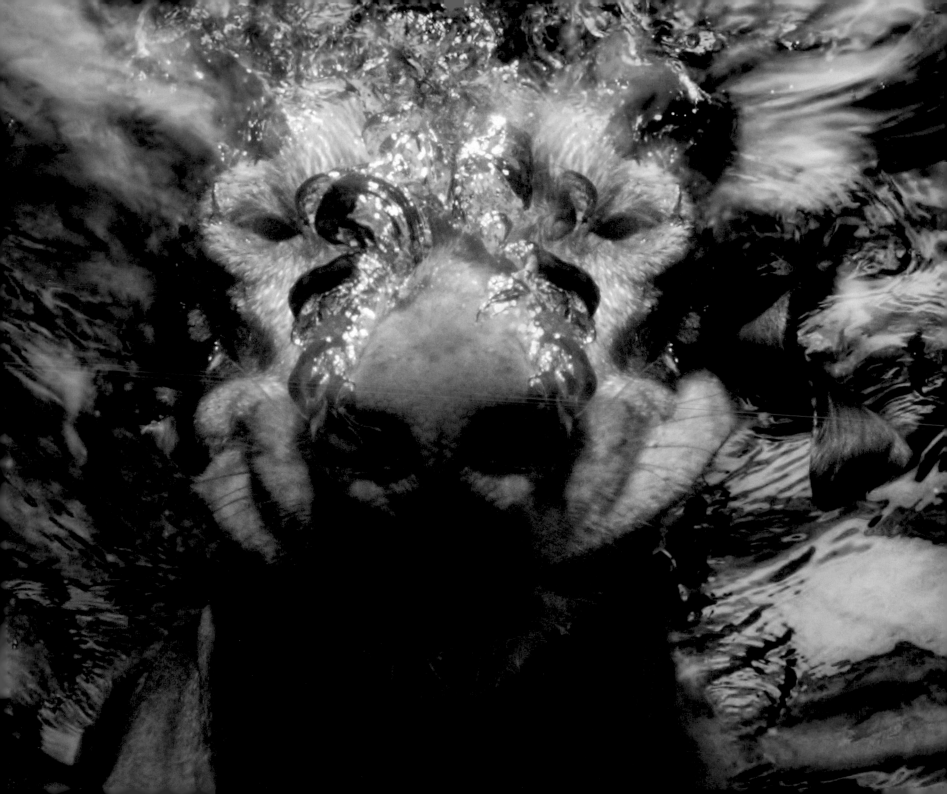

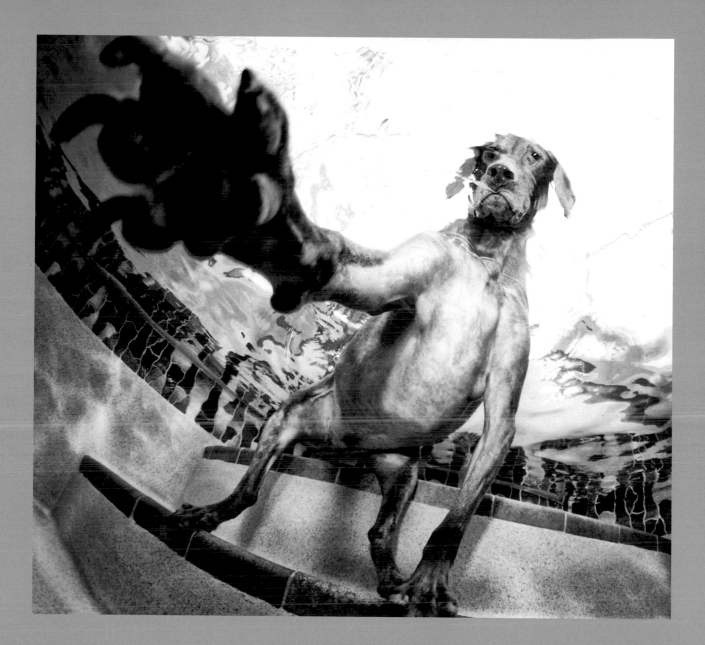

Tatum
Vizsla, 5 years

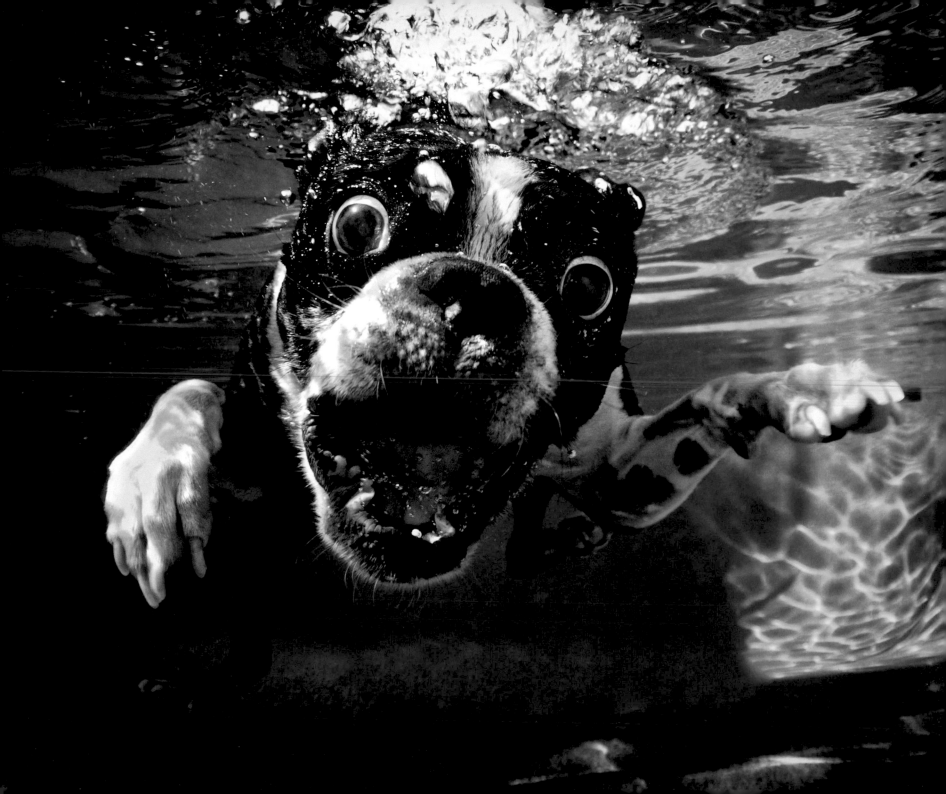

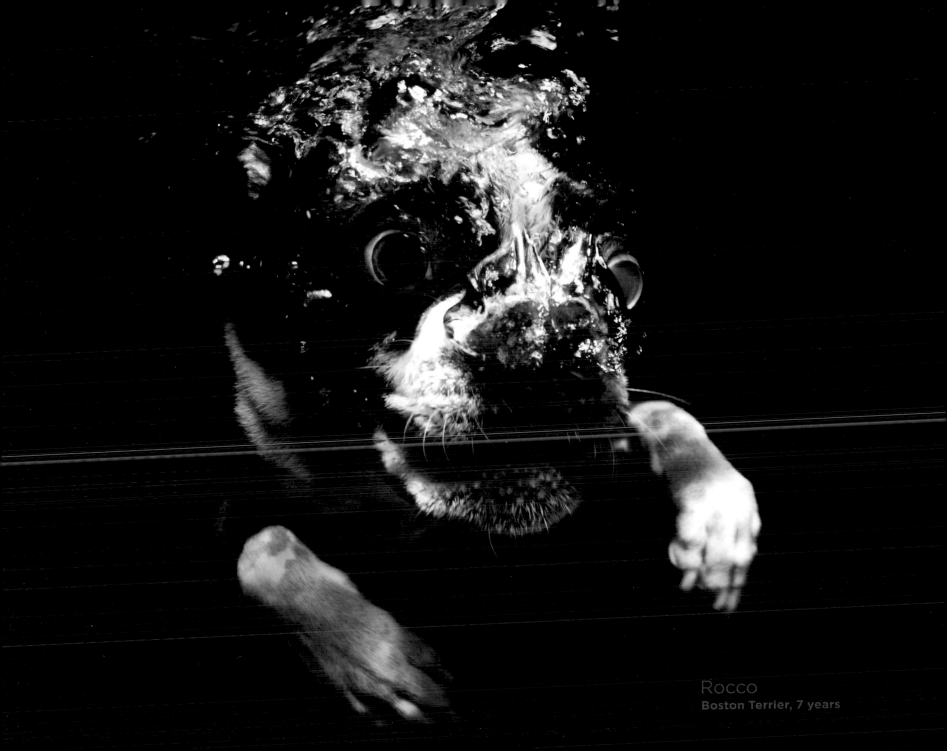

Rocco
Boston Terrier, 7 years

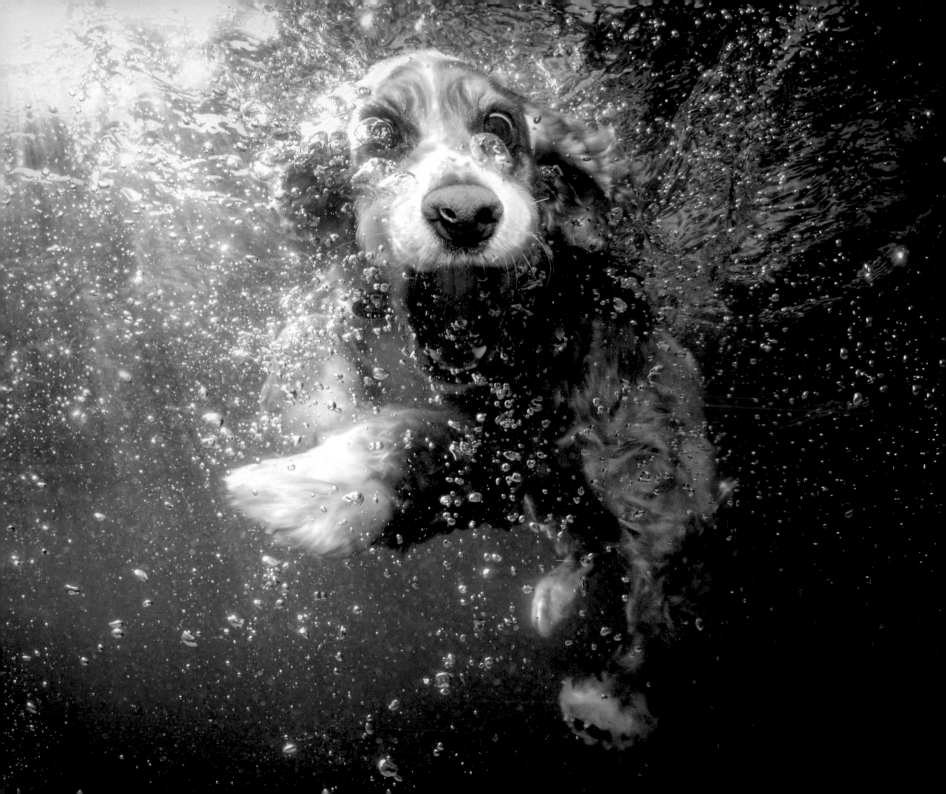

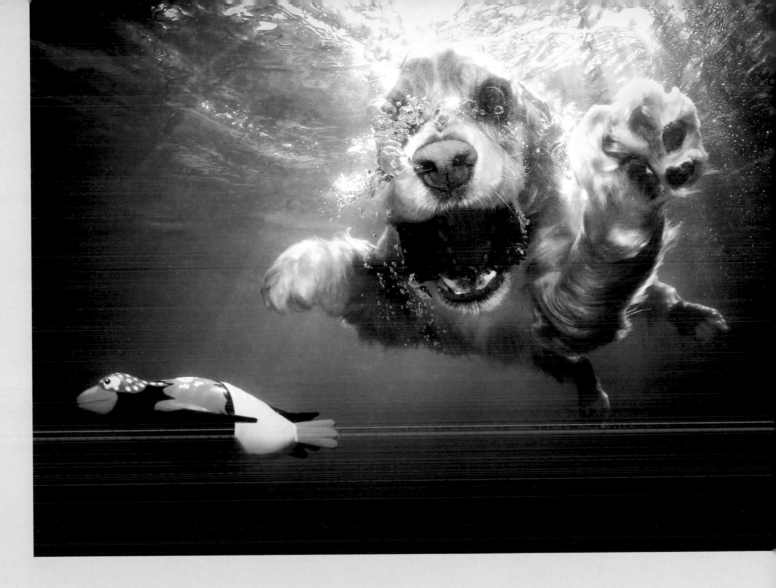

Oshi
Cocker Spaniel, 6 years

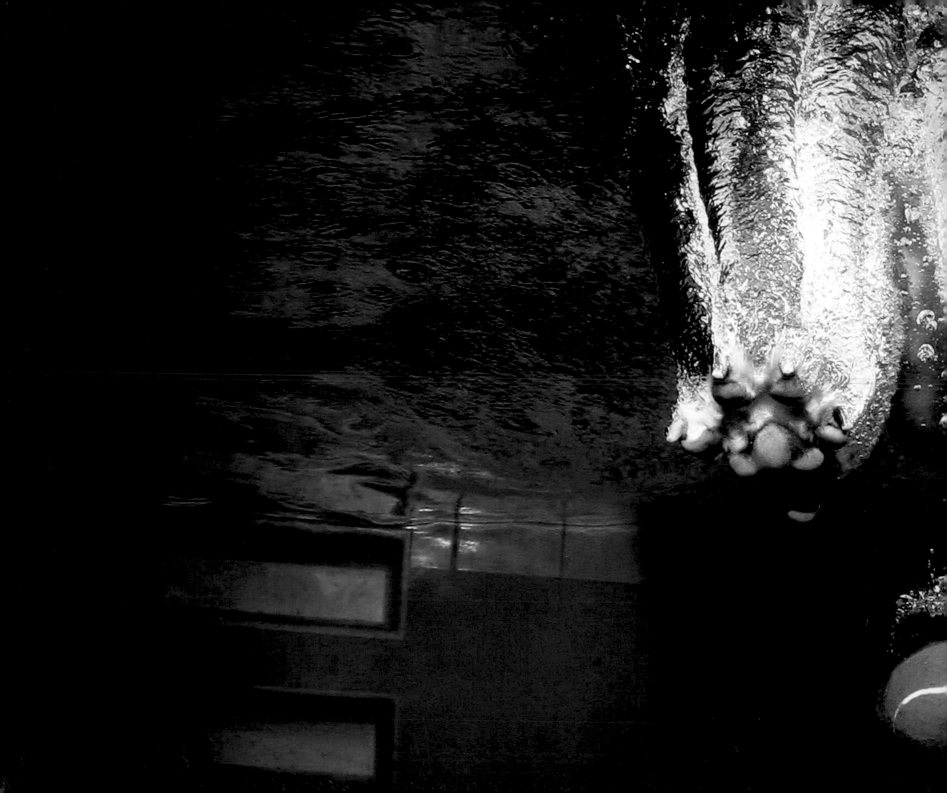

Warden
Labrador Retriever, 11 months

The Dogs on Land

Alex

Apollo

Banshee

Bardot

Bear

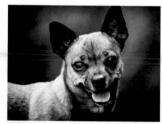

Bella

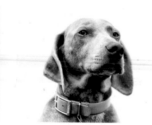

Bella

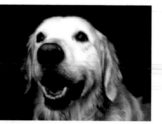

Ben

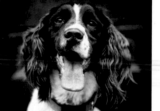

Birdie

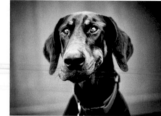

Blade

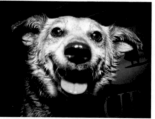

Bob

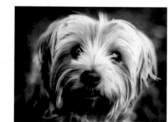

Brady

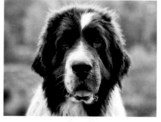

Bristles

Bullet

Buster

Callaway

Charlie

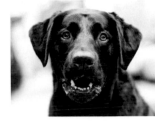

Charlie

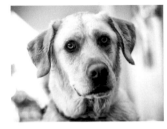

Chloe

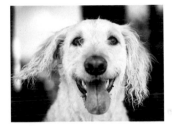

Clifford

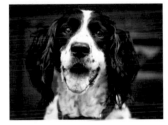

Clive

Clyde

Comet

Coraline

Dagmar

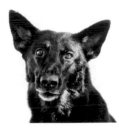

Dakota

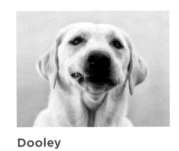

Dooley

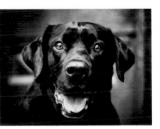

Duchess

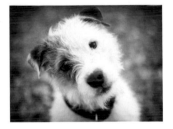

Duke

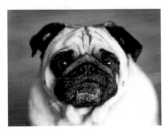

Duncan

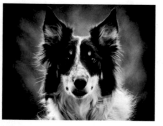
Fleet

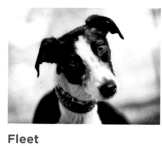
Foster

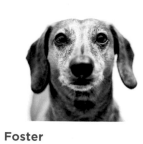
Gidget

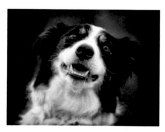
Glory

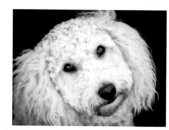
Grayson

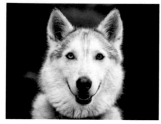
Gunnar

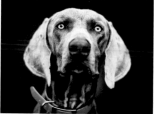
Gunner

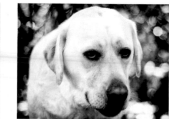
Herbie

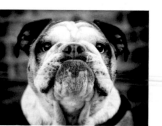
Jackie

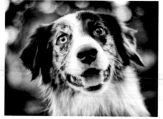
Jake

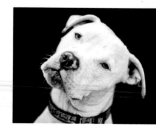
Jigger

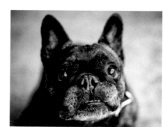
Jolie

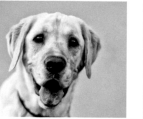
King

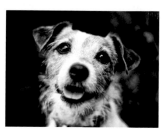
Kona

Lulu

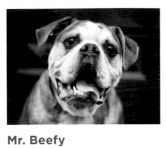

Mr. Beefy

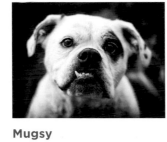

Mugsy

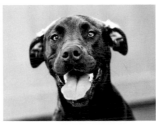

Murphy

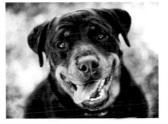

Mylo

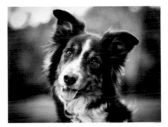

Nevada

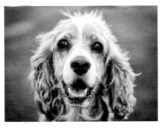

Oshi

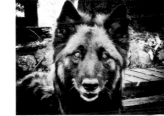

Raika

Ralphie

Rarity

Remi

Rex

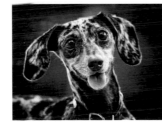

Rhoda

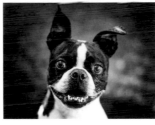

Rocco

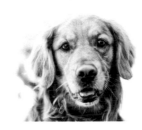

Rowdy

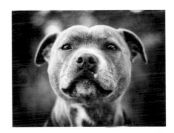

Sadie

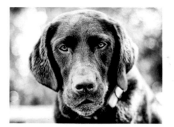

Scout

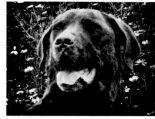

Stanley

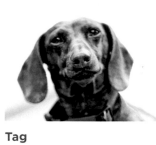

Tag

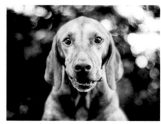

Tatum

Tracer

Victor

Warden

Wrigley

Acknowledgements

Nala the Mini-Labradoodle

Madison the Finnish Spitz

Fritz the Norwich Terrier

Duchess the Dachshund

My family and friends for supporting my crazy adventures

Eva

Andrea Pelose

Michelle Tessler of Tessler Literary Agency

John Parsley and the wonderful folks at Little, Brown and Company

Ian Shive, Jon-Paul Harrison, and Tandem Stills + Motion

Scott Stulberg and Holly Kehrt

Walt Disney

John Z. DeLorean

Jill

Natural Healing Whole Dog Wellness

Doglando

Buster, Nevada, and Bardot

A special thanks to all the amazing people who help animals! You make
 the world a better place!

About Seth Casteel

Seth Casteel is an award-winning photographer with a passion for working with animals. His underwater dog photographs have brought him worldwide attention, entertaining and fascinating millions of animal lovers. As an established member of the animal-rescue community, Casteel has been recognized for his efforts by *Time*, the *Today* show, and the Humane Society of the United States, and his underwater dog photographs have been featured in the *New York Times*, on Animal Planet, and in hundreds of other outlets. He is based in Los Angeles and Chicago and is the proud "dad" to two dogs, Nala the Mini-Labradoodle and Fritz the Norwich Terrier.